TALL *in the* SADDLE

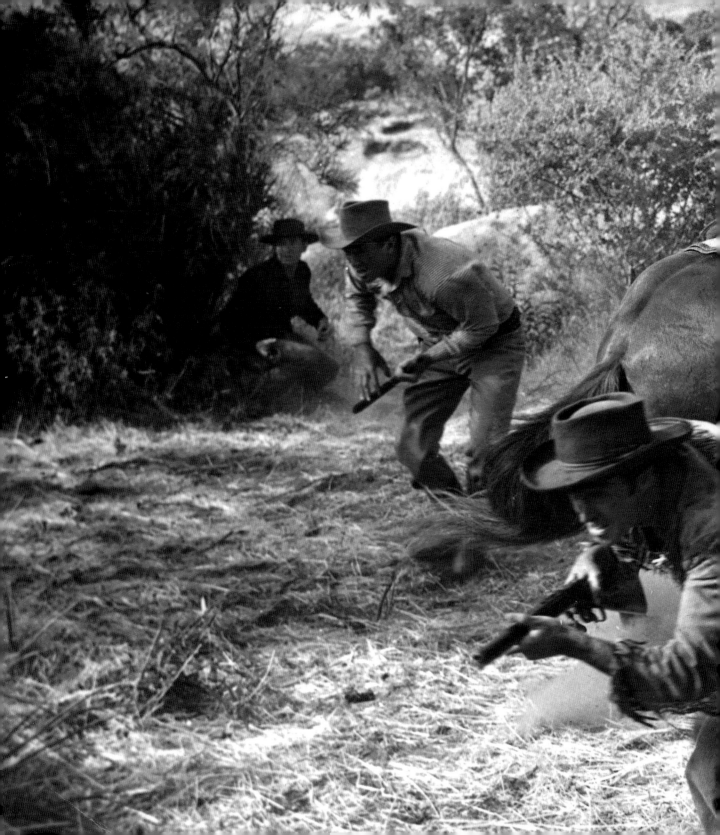

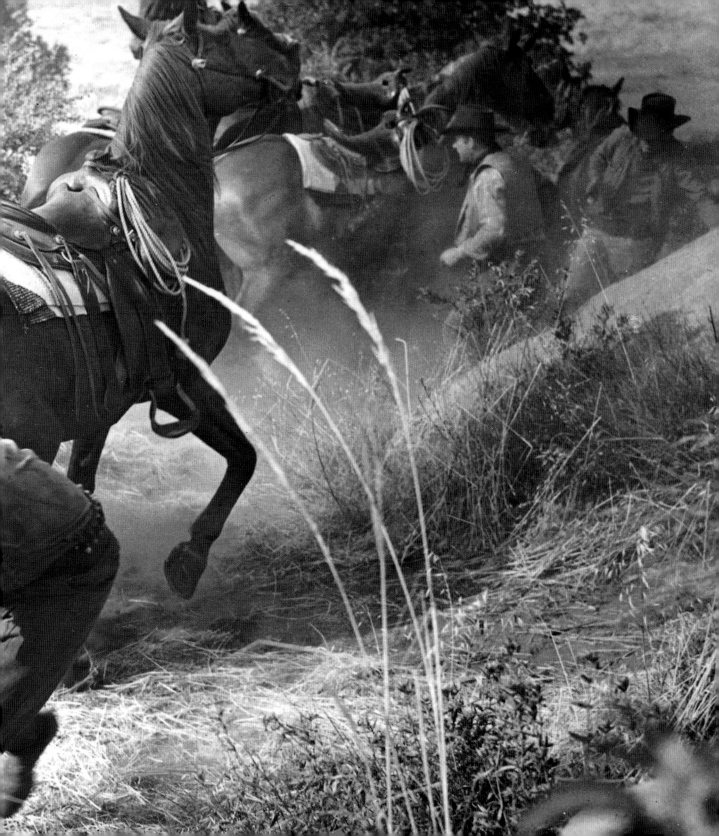

TALL *in the*

PEGGY THOMPSON

& SAEKO USUKAWA

SADDLE

GREAT LINES FROM CLASSIC WESTERNS

CHRONICLE BOOKS

SAN FRANCISCO

DEDICATED TO THE MEMORY OF

Justin Caulder

Pages ii–iii: In *Kansas Pacific,* Capt. John Nelson (Sterling Hayden) hits the ground running, rifle at the ready, to fight off Quantrill's Raiders, Confederate guerrillas who want to stop the railroad from going through.
Opposite: A drifter from Texas named Morgan (Alan Ladd) straps on his guns to lead cattlemen in a fight against a scheming buyer who is forcing prices down to ridiculous levels in *The Big Land* (1957).
Front inside cover: In *Angel and the Badman,* it's the woman, Penny Worth (Gail Russell) who gets the man, outlaw Quirt Evans (John Wayne). First she dresses his wounds and nurses him back to health, then she reforms him.
Back inside cover: The Charge at Feather River (1953) was a 3-D western, with arrows and fists flying out at the audience.

Printed in Hong Kong.

Library of Congress Cataloging-in-Publication Data:

Thompson, Peggy, 1953–
 Tall in the saddle: great lines from classic westerns / by Peggy Thompson and Saeko Usukawa.
 p. cm.
 ISBN 0-8118-1730-X (pbk.)
 1. Western films—Quotations, maxims, etc.
 I. Usukawa, Saeko, 1946–
 II. Title.
 PN1995.9.W4T56 1998
 791.43'6278—dc21 97-28751
 CIP

Published in Canada by Greystone Books
A Division of Douglas & McIntyre
1615 Venables Street
Vancouver, British Columbia V5L 2H1

A Byzantium Book
Art direction: Barbara Hodgson
Book and cover design: Isabelle Swiderski
Composition: Byzantium Books
Front cover photograph: *Along Came Jones* ©1945 United Artists Corporation. All rights reserved.
Back cover photographs: top, *Roughshod* (1949); bottom, *Mark of Zorro* (1920)

10 9 8 7 6 5 4 3 2 1

Chronicle Books
85 Second Street
San Francisco, CA 94105
Web Site: www.chronbooks.com

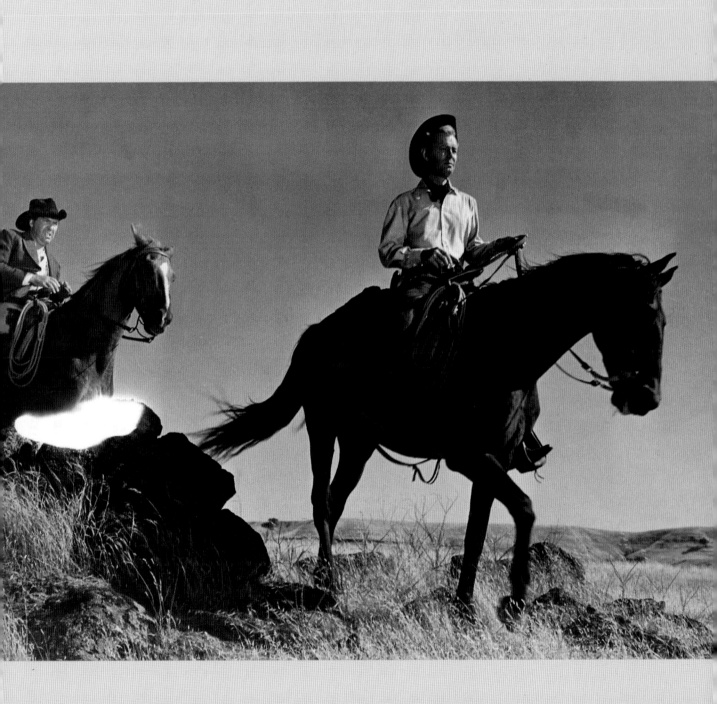

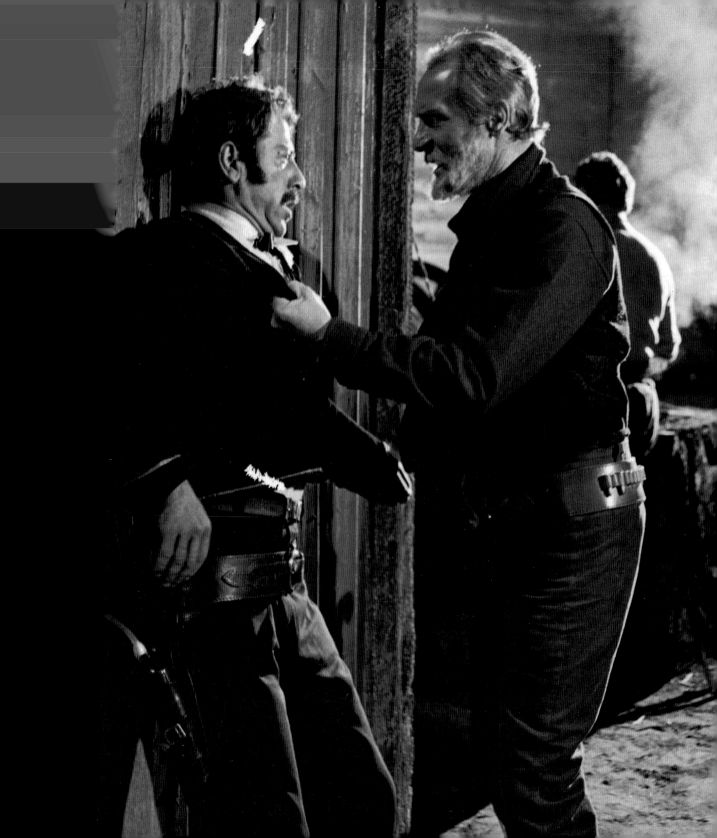

Introduction

"A gun is as good or as bad as the man using it," says Alan Ladd as the mysterious, buckskin-clad stranger in *Shane*. "There's some things a man just can't run away from," drawls a young John Wayne to his terrified fellow passengers in John Ford's *Stagecoach*. "Draw fast and aim slow," quips Richard Dix as Wyatt Earp in *Tombstone*.

The West and the western are the stuff of legend—and American movies. Since the birth of motion pictures just over a century ago, more than 7,000 western films have been made. That's a lot of cowboys, cattle, wagon trains, and shoot-outs.

The birth of the western was almost simultaneous with that of moving pictures themselves, and some of the first silents—produced by inventor Thomas Edison—were documentaries showing cowboys, Indians, and the West. Edison also produced *The Great Train Robbery*, one of the first westerns with a narrative. The golden age of the western began in the 1930s and arguably ended in the late 1960s, with films like *The Wild Bunch, Little Big Man,* and *Hud* sounding a eulogy for the death of the wide-open West. The gritty realism of the '70s and the vapid blockbusters of the '80s gave way in the '90s to revisionist interpretations.

In the western film, history and legend combine to form a genuine American genre. Instead of Athens and Troy, the settings for these myths are places like Tombstone, Death Valley, the Chisholm Trail, and the O.K. Corral. Instead of

Opposite: A violent confrontation between two gunmen in *Shotgun* (1955). The script was written by Rory Calhoun, who starred in many westerns, including *River of No Return* and *Apache Uprising*.

ancient gods and goddesses, the heroes and heroines are often based on real people with names like Wild Bill Hickok, Buffalo Bill Cody, Calamity Jane, Billy the Kid, Doc Holliday, and Sitting Bull.

Full of set pieces and stock characters such as the lone cowboy, the tart with a heart, the drunken doctor, the corrupt judge, the brutal gunslinger, the refined schoolteacher, and the "good" badman, the genre developed in upon itself, in all its repetitive yet reassuring glory. After all, what western would be complete without at least a brawl in a saloon, a chase over the open plain, a gunfight, or a cattle stampede? But as in all myths, stock characters and actions have an important function in the telling of the tale, providing a recognizable backdrop against which great moral dilemmas can play out. Sometimes the action takes place in lawless cowtowns that need cleaning up. Sometimes it occurs high in the mountains where wild horses still roam free. Out on the plains, the seas of grass provide dramatic vistas for wagon trains and stagecoaches rolling through the lands of hostile Indians and past lone forts manned by cavalry troops. The sweeping, wide-open landscape, which people called "big sky country," is part of the western myth. As cattleman Virgil Renchler (played by Orson Welles) boasts in *Man in the Shadows*, "Over in Europe, there aren't five or six countries as big as this ranch."

Folksy and tough, with an occasional touch of humor, the dialogue is unmistakably American. The folksiness (and underlying toughness) are there in lines such as "I wouldn't trust you with a snowball in a blizzard" (from *A King and Four Queens*) and aphorisms like "A man's gotta do his own growin' no matter how tall his father was" (from *Gun Fury*). And there's never a shortage of threats: "You're not leaving town until dead men can walk" (from *The Plainsman*). The deadpan humor and wisecracks typify the gumption needed to face life on the frontier: "Some people call this hell. But you're still in Oklahoma Territory" (from *Hang 'em High*).

The central myth of the West is the lure of the frontier. As "civilization" moved westward across America, conflicts arose between the law and the lawless, between order and wildness. Films such as *High Noon, Gunfight at the O.K. Corral,* and *Dodge City* are all about taming the Wild West, making it a fit place for decent

people. When towns like Tombstone or Deadwood became overrun with gunslingers, sooner or later James Stewart or Henry Fonda or John Wayne would arrive on a dusty horse, and sooner or later that six-gun by his side would be spitting bullets to restore law and order. Then he'd marry and settle down. In other films, such as *Stagecoach, Shane,* and *A Fistful of Dollars*, the heroes don't stay and settle down. Instead, the dream of living free lives carries them farther into country that is still "untamed," as they ride ever westward into the sunset.

The myth of the American West appeared for the first time in books, and over the years many western novels and stories have been turned into movies. The father of the western novel was James Fenimore Cooper, whose popular novels, including *The Last of the Mohicans*, were published between the 1820s and 1840s and featured a hero loosely based on frontiersman Daniel Boone. The lurid dime novels that began appearing in the 1860s made heroes out of real people such as Calamity Jane and Wild Bill Hickok by romanticizing their lives and inventing sensational escapades. Interest in the West was further fueled by touring Wild West shows in the 1870s and 1880s, especially Buffalo Bill Cody's, which starred living legends Annie Oakley and Sitting Bull. Newspapers of the day added breathless accounts of the exploits of outlaws Jesse James, Billy the Kid, and Cole Younger. Next came Owen Wister and his popular novel about the West, *The Virginian*, which was made into a movie of the same name in 1929, starring a very young Gary Cooper. After Wister came a herd of popular western authors including Zane Grey, Max Brand, Louis L'Amour, and Luke Short.

Starting with the days of the silent film, westerns were already popular. William S. Hart, the leading star of silent westerns from 1914 to 1921, often played an outlaw reformed by the love of a good woman. He was followed by Tom Mix, an ex-rodeo rider, who wore fancy outfits and specialized in spectacular stunts.

The 1930s were the heyday of the action-packed, stunt-filled westerns, fondly called "oaters," "horse operas," and "shoot-em-ups," with good guys (wearing white hats) and bad guys (wearing black hats) chasing each other back and forth

over the range. Hundreds of these low-budget B westerns, shot in just a week or two, were churned out by Republic, Monogram, and a handful of smaller studios, with stars like William Boyd, better known by his character's name of Hopalong Cassidy. These sagebrush sagas were thin on plot, characterization, and romance, but full of stunts and displays of horsemanship; many also featured at least one minor character (often the hero's sidekick) who supplied comic relief, or a song sung by one of the actors. In fact, during the late '30s and early '40s, Gene Autry, the singing "King of the Cowboys," was a popular star. He was succeeded by Roy Rogers, another singing cowboy, who continued to make uncomplicated B westerns throughout the 1950s. The popularity of cowboy ballads led to "country and western" music and eventually country music.

Of all the directors who left their mark on the western, John Ford may be the most important. His *Stagecoach*, released in 1939, has been called the first modern or "adult" western because of its complex characters (including a prostitute as the heroine) and its celebration of the grandeur of the setting. The young John Wayne plays an outlaw, the Ringo Kid, seeking vengeance for the murder of his brother and father. Also aboard the stagecoach are Claire Trevor as the prostitute and Thomas Mitchell as an alcoholic doctor. These three social outcasts save their snobbish fellow passengers when the stagecoach is attacked. The film ends with Wayne and Trevor heading off into the wilderness, where they'll be free from the so-called blessings of civilization. *Stagecoach* made John Wayne into a major star.

Throughout the 1940s, westerns continued in popularity with the usual outpouring of formulaic B movies, along with a number of classics such as *My Darling Clementine, Fort Apache, The Ox-Bow Incident, Pursued, Red River, Tombstone,* and *The Westerner*. Released in 1943, *The Ox-Bow Incident* is considered to be the first "antiwestern" because of its grim theme—mob violence—and its grimmer ending, when a kangaroo court condemns and hangs three innocent men. In 1948, *Broken Arrow*, James Stewart's first serious western, was one of the first movies since *The Vanishing American* (1925) to question the stereotyped portrayal of Native Americans by showing history from their point of view.

In the 1950s, westerns flourished as never before. Directors like Delmer Daves, Anthony Mann, Samuel Fuller, Howard Hawks, Nicholas Ray, and Budd Boetticher made many of the genre's most exciting films. In contrast to the optimism and action of early westerns, the trend to the darker, more complex themes and moral ambiguity introduced in the 1940s continued with great films like *The Gunfighter*, *High Noon*, and *Shane*. In these as well as others, values became more complex, making it increasingly difficult to tell the good guys from the bad guys.

Some of the greatest westerns appeared in the 1960s, beginning with *The Magnificent Seven*, an immensely popular movie produced and directed by John Sturges, based on Akira Kurosawa's *Seven Samurai*. Many other movies made during that decade, such as *Ride the High Country*, *Lonely Are the Brave*, *The Wild Bunch*, *Hud*, *The Misfits*, and *Butch Cassidy and the Sundance Kid*, explored the inevitable, inexorable end of the frontier, often ending in a hail of bullets that killed both the last good men and the remaining outlaws. They mourned the passing of a kind of openness—and the devastating loss of western ideals such as freedom and self-reliance—while proving, ironically, that the western itself was far from dead. Meanwhile, in Italy, Sergio Leone was reinventing the form with the seriocomic, violent trilogy about the Man with No Name, starring Clint Eastwood: *A Fistful of Dollars*, *For a Few Dollars More*, and *The Good, the Bad and the Ugly*.

For decades—almost since its birth, in fact—critics and fans have regularly declared the western dead. So far, however, it has managed to keep reinventing itself. Most recently there was the highly acclaimed and hugely successful *Dances with Wolves* as well as *Unforgiven*.

This book, *Tall in the Saddle*, offers a chance to look back—through images and dialogue—at the decades of classic westerns celebrating that most American of all myths, the myth of the frontier. Westerns not only influenced the way people think, they also influenced the way we dress and the way we talk. Reading—and quoting—the frank, funny, poignant, and occasionally bawdy lines remind us of that independent western spirit, that cowboy or cowgirl inside each of us.

Background: Director William S. Porter's *The Great Train Robbery* (1903), produced by Thomas Edison, was the most famous of all the early westerns.

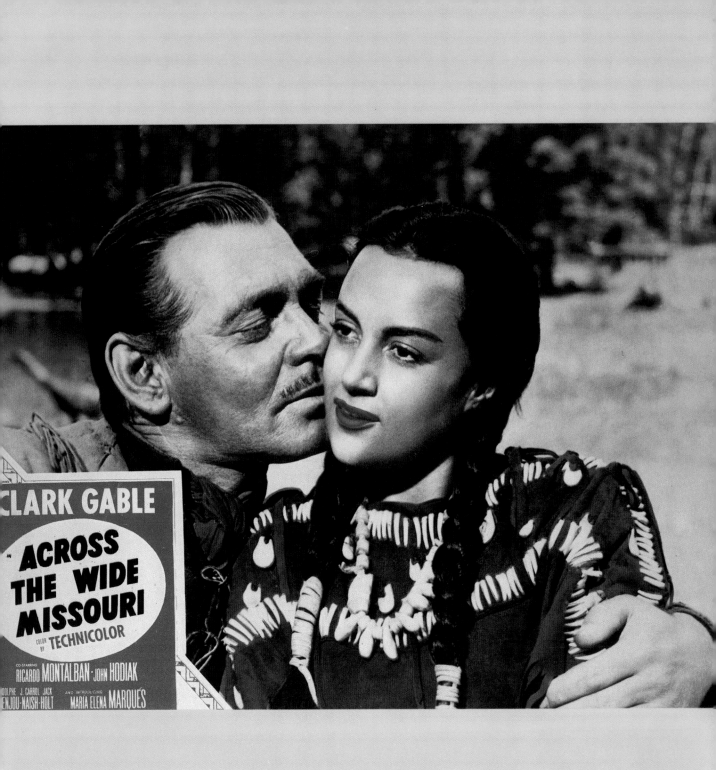

CLARK GABLE

"ACROSS
THE WIDE
MISSOURI
COLOR BY TECHNICOLOR

CO-STARRING RICARDO MONTALBAN · JOHN HODIAK
ADOLPHE J. CARROL JACK
ENJOU-NAISH-HOLT AND INTRODUCING MARIA ELENA MARQUES

Across the Wide Missouri•1959

"Trees lie where they fall. And men are buried where they died."

—narrator, the son of mountain man Flint Mitchell (Clark Gable) and Native American princess Kamiah (Maria Elena Marques)

"You know all about the mountain. But you know nothing about the woman. But you will learn, maybe."

—Pierre (Adolphe Menjou) to mountain man Flint Mitchell (Clark Gable) on his wedding night

The Alamo•1960

"You never pray, do you, Davy?"
"I never found the time."

—Parson (Hank Worden) and Davy Crockett (John Wayne)

"I give thanks for the time and the place."
"The time and the place, Parson?"
"A time to live and a place to die. That's all any man gets. No more, no less."

—Parson (Hank Worden) to boy (bit player)

"There's right and there's wrong. You gotta do one or the other. You do the one, and you're living. You do the other, and you may be walking around, but you're dead as a beaver hat."

—Davy Crockett (John Wayne)

"I've been given command of the armies of Texas. Now, the fly in the buttermilk is there ain't no armies in Texas."

—Sam Houston (Richard Boone)

"I'm a stranger 'round these here parts. What do you Texans use for drinking whiskey?"
"Drinking whiskey."

—Capt. Almeron Dickinson (Ken Curtis) and Beekeeper (Chill Wills)

Opposite: In *Across the Wide Missouri,* trapper Flint Mitchell (Clark Gable) marries a Blackfoot chief's daughter, Kamiah (Maria Elena Marques, a Mexican film star). Director William Wellman also made the classic *The Ox-Bow Incident.*

Along Came Jones

1945

"That's just to show you when I aim at something, I hit it. And when I hit something, that's what I aimed at."
—Cherry de Longpre (Loretta Young) to Melody Jones (Gary Cooper), showing off her sharpshooting

"Don't go far, will ya? I don't aim to be drinking here for more than five or six hours."
—cowboy George Fury (William Demarest) to his pal Melody Jones (Gary Cooper)

"You gotta look like you're somebody and act like you're somebody. Like you can take care of yourself no matter what happens. You do that, pretty soon you *are* somebody."
—cowboy Melody Jones (Gary Cooper) to his pal George Fury (William Demarest)

Courtesy of MGM Consumer Products

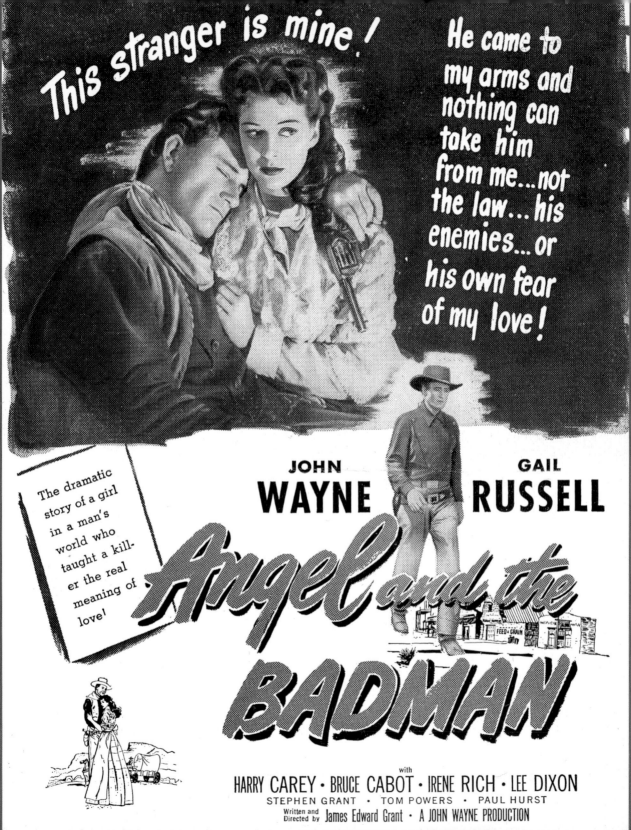

Angel and the Badman • 1947

"I got places to go and country to put behind me."

—badman Quirt Evans (John Wayne)

"He's quite a man with the girls. They say he's closed the eyes of many a man and opened the eyes of many a woman."

—telegraph operator (bit player) to Penny Worth (Gail Russell) about badman Quirt Evans (John Wayne)

"This isn't civilized Pennsylvania, this is the raw frontier—this is a place where mayhem, theft and murder are the commonplace instead of the unusual."

—Dr. Mangram (Tom Powers) to settler Mrs. Russell (bit player)

"I'm a good loser."
"I like a good loser. 'Course I like any kind of loser better than a winner."

—badman Laredo Stevens (Bruce Cabot) to badman Quirt Evans (John Wayne)

Apache • 1954

"Even a hawk is an eagle among crows."

—Chief Santos (Paul Guilfoyle) to his daughter Nalinle (Jean Peters)

Apache Uprising • 1966

"I don't aim to end toes-up to the sun."

—outlaw Jess Cooney (Gene Evans) to robber Toby Jack Saunders (DeForest Kelley)

"She'll find nothing but contempt and scorn in this territory. Her reputation goes ahead of her."
"And lingers after her."

—bartender Henry Belden (Donald Berry) and Hoyt Talor (Robert H. Harris)

"I ain't such a bad cuss once you get to know me."
"I'll forgo that pleasure, if you don't mind."

—robber Jess Cooney (Gene Evans) and Janis McKenzie (Corinne Calvet)

"*You* killed him. *You* get him out of here."

—Vance Buckner (John Russell) to fellow outlaw Toby Jack Saunders (DeForest Kelley)

Arizona • 1940

"There'll be no killing in my place."
"Since when? Since this morning?"

—bar owner Lazarus Ward (Porter Hall) and hellcat Phoebe Titus (Jean Arthur)

Preceding pages, left: The gun-shy Melody Jones (Gary Cooper) and sharp-shooting Cherry de Longpre (Loretta Young) are ready to fight outlaw Monte Jarrad (Dan Duryea) in *Along Came Jones,* based on Alan LeMay's novel *Useless Cowboy.*
Preceding pages, right: Melody Jones (Gary Cooper) kisses Cherry de Longpre (Loretta Young) after she saves his life in *Along Came Jones.* Cooper himself produced this comedy western.
Opposite: In *Angel and the Badman,* outlaw Quirt Evans (John Wayne) is reformed by the love of a pacifist but strong-willed Quaker woman, Penny Worth (Gail Russell).
Page 6: Army deserter Bart Laish (Sterling Hayden) redeems himself by taking on the identity of a dead army major in order to save a wagon train in *Arrow in the Dust.*
Page 7: Town bully Reno Smith (Robert Ryan) and town drunk Doc Velie (Walter Brennan) share a guilty secret in *Bad Day at Black Rock.* Director John Sturges also made the classic *High Noon.*

"Someday, Judge Bogardus, the law will
 come to Arizona and half of you will
 be hung."
"Miss Phoebe, you belittle us. Ninety
 per cent."
—hellcat Phoebe Titus (Jean Arthur) and Judge Bogardus
(Edgar Buchanan)

Arrow in the Dust • 1954
"It doesn't matter what you've been,
what you've done. There must be
some good left in you."
—dying Major Andy Pepperidge (bit player) to army
deserter Bart Laish (Sterling Hayden)

Bad Day at Black Rock • 1955
"I'll only be here twenty-four hours."
"In a place like this, that could be a
 lifetime."
—passenger John J. McReedy (Spencer Tracy) and train
conductor (bit player)

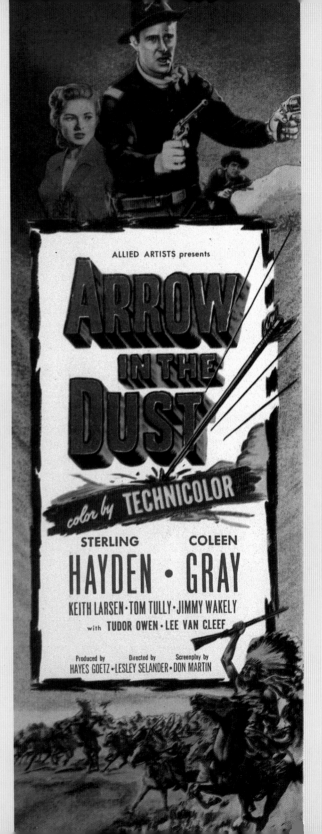

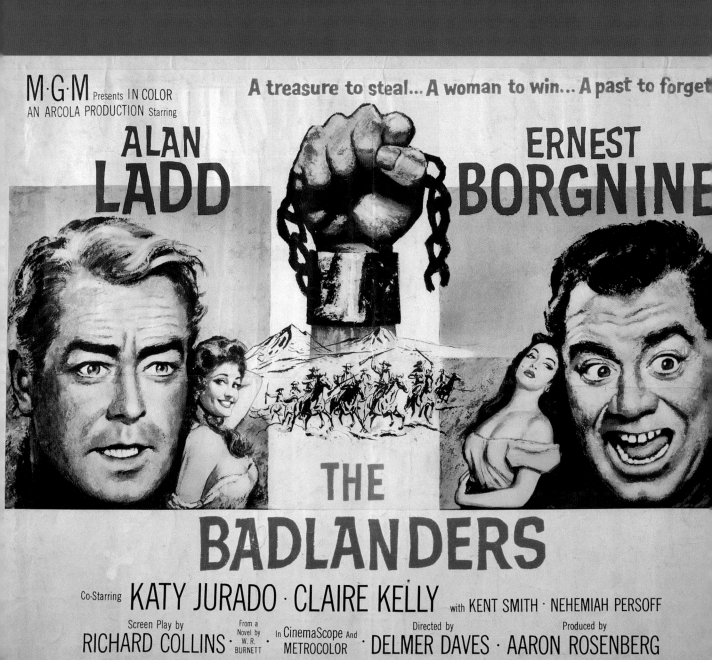

"I feel for you, but I'm consumed with apathy."
—town drunk Doc Velie (Walter Brennan) to one-armed stranger John J. McReedy (Spencer Tracy)

"You're so scared you'd probably drown in your own sweat."
—killer Reno Smith (Robert Ryan) to one-armed stranger John J. McReedy (Spencer Tracy)

The Badlanders•1958

"Unless you want to see your own gravestone on your way to hell, you'll be on the next stage."
—town marshal (bit player) to ex-con Peter "Dutchman" Van Hock (Alan Ladd)

The Ballad of Cable Hogue•1970

"Give me that rifle."
"I'll give you what's in it. Now get out."
—cowboy (bit player) and Cable Hogue (Jason Robards Jr.)

"Careful, son, I'm a man of God."
"Well, you damn near joined him."
—Rev. Joshua Duncan Sloane (David Warner) and Cable Hogue (Jason Robards Jr.)

"Honey, you were smelling bad enough to gag a dog on a gut wagon."
—prostitute Hildy (Stella Stevens) to Cable Hogue (Jason Robards Jr.)

"Taggart Vaughn left me out there to die. If my feet don't get cold and my back don't turn yellow and my legs'll stand under me, I aim to kill him for it. I don't call that a passion."
"Vengeance is mine, saith the Lord."
"Well, that's fair enough with me. Just as long as he don't take too long and I can watch."
—Cable Hogue (Jason Robards Jr.) and Rev. Joshua Duncan Sloane (David Warner)

Opposite: The Badlanders was a western version of one of three films based on W. R. Burnett's noir novel *The Asphalt Jungle.* Director Delmer Daves was noted for his westerns, including *Jubal* and *3:10 to Yuma.*
Below: The falsely imprisoned Peter "Dutchman" Van Hock (Alan Ladd) drags fellow convict John McBain (Ernest Borgnine) to shore after knocking him out in a fight in *The Badlanders.* Ladd also starred in the classic western *Shane.*

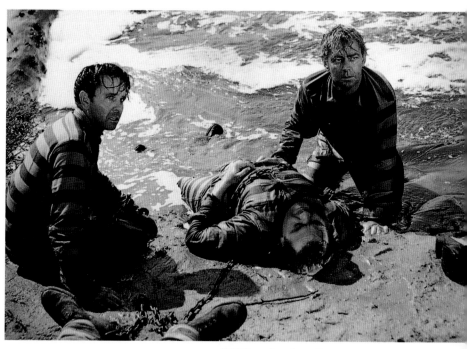

©1958 Turner Entertainment Co.

Left: Outlaw Jeff Clanton (Robert Ryan) and the Younger gang confront the law in *Best of the Badmen.* Ryan, who starred in many film noirs, also appeared in classic westerns such as *Bad Day at Black Rock* and *The Wild Bunch.*

The Beautiful Blonde from Bashful Bend • 1949

"Never wait too long between shots, or your finger might change its mind. And shooting ain't got nothing to do with the mind."

—old-timer (Russell Simpson) to his young granddaughter (Mary Monica MacDonald)

"You ought to be ashamed of yourself, doing that to another girl. I mean, I don't care what you do to a man, but to another girl!"

—dance hall girl Freddie Jones (Betty Grable) to her sidekick Conchita (Olga San Juan)

"Well, dog my cats, it's Jo-Jo the dog-faced boy."

—bully Gus Basserman (Richard Hale) to Charlie Hingleman (Rudy Vallee)

Best of the Badmen • 1951

"Do what I tell you, and you'll always go wrong."

—Mrs. Lily Fowler (Claire Trevor)

"What have you got agin' the Major? He never did nothin' to you."

"I just figure he walks too tall for his size. Somebody might have to cut him down."

—Doc Butcher (Walter Brennan) and Curly Ringo (John Archer)

The Big Country • 1958

"Miss Terrill, aren't you going to introduce me to your fiancé?"

"I wouldn't introduce you to a dog."

—lout Buck Hannassey (Chuck Connors) and Patricia Terrill (Carroll Baker)

"No prettier sight in the world than 10,000 head of cattle—unless it's 50,000."

—rancher Maj. Henry Terrill (Charles Bickford) to Jim McKay (Gregory Peck)

"You know, Julie, I could just picture us together out in the Big Muddy. The lamp lit, you cooking, me eating. Happy as two little doggies in a warm hole."

"I'm enchanted."

—lout Buck Hannassey (Chuck Connors) and schoolteacher Julie Maragon (Jean Simmons)

A Big Hand for the Little Lady • 1966

"I wouldn't play poker with Henry Drummond if his back was to a mirror!"

—stagecoach driver Sparrow (Noah Keen) to hotel owner Sam Rhine (James Kenny)

The Big Sky • 1952

"Only thing they're feared of is the white man's sickness."

"What's that?"

"Grabs. White men don't see nothin' pretty unless they want to grab it. The more they grab, the more they want to grab. It's like a fever and they can't get cured. Only thing for them to do is keeping on grabbing till everything belongs to white men, and then they start grabbing from each other."

—frontiersman Uncle Zeb (Arthur Hunnicut) and newcomer Jim Deakins (Kirk Douglas)

"Sure is big country. The only thing bigger is the sky."

—scout Jim Deakins (Kirk Douglas) to his buddies

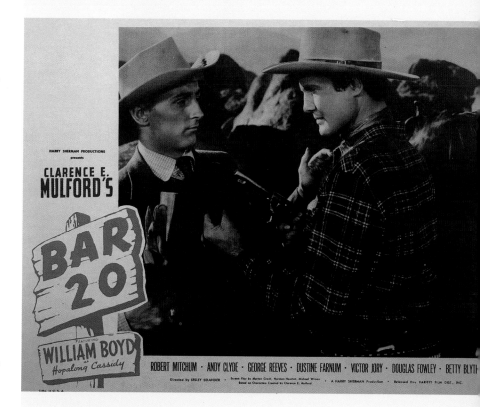

Bar 20 Justice • 1938

"I'm going into town. I've got a little forgetting to do."

—Lucky Jenkins (Russell Hayden) to Windy Halliday (Gabby Hayes)

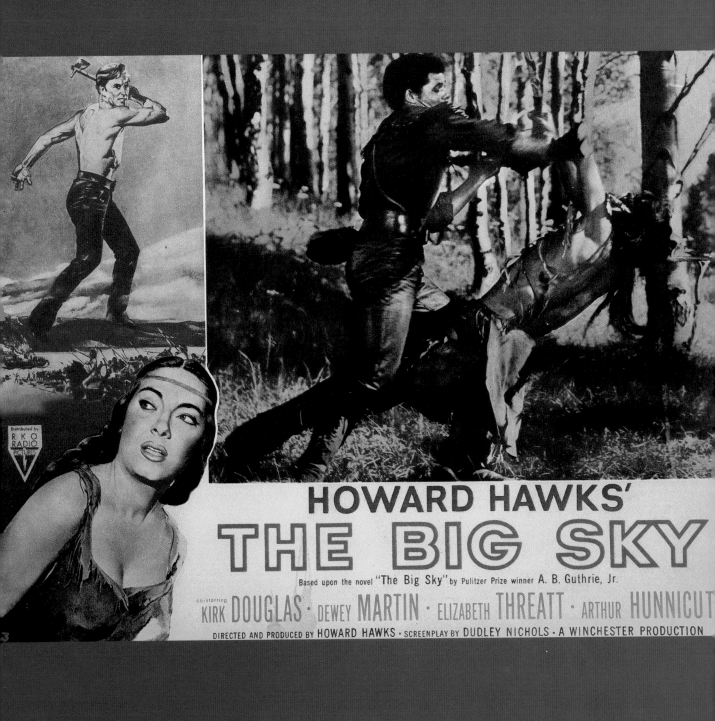

HOWARD HAWKS'
THE BIG SKY
Based upon the novel "The Big Sky" by Pulitzer Prize winner A. B. Guthrie, Jr.

co-starring KIRK DOUGLAS · DEWEY MARTIN · ELIZABETH THREATT · ARTHUR HUNNICUT

DIRECTED AND PRODUCED BY HOWARD HAWKS · SCREENPLAY BY DUDLEY NICHOLS · A WINCHESTER PRODUCTION

Distributed by
R K O
RADIO
PICTURES

The Big Trail•1930

"Whenever I get more than three or four families within a hundred miles of me, I begin to feel kind of crowded."

—old-timer Zeke (Tully Marshall) to Ruth Cameron (Marguerite Churchill)

"You know, you can get sort of used to having somebody not like you."

—wagon train scout Breck Coleman (John Wayne) to southern lady Ruth Cameron (Marguerite Churchill)

"When a man begins to do a lot of talking about hanging, he'd better make pretty sure as to who's going decorate the end of the rope."

—old-timer Zeke (Tully Marshall) to Red Flack (Tyrone Power Sr.)

Broken Arrow•1950

"You know what I am thinking? Maybe some day you will kill me or I will kill you, but we will not spit on each other."

—Apache Chief Cochise (Jeff Chandler) to Capt. Tom Jeffords (James Stewart)

"Why, this is delicious. What is it?"
"Pony. In your honor, General."
"Pony. What kind of meat's that?"
"A pony is small horse, General."

—General Howard (Basil Ruysdael) and Capt. Tom Jeffords (James Stewart)

Broken Lance•1954

"Just brand 'em, don't barbecue 'em."

—rancher Matt Devereaux (Spencer Tracy) to cowboy (bit player)

"Get a gun or get out of town."

—rancher Matt Devereaux (Spencer Tracy) to a lawyer (bit player)

Butch Cassidy and the Sundance Kid•1969

"Well, looks like you just about cleaned everybody out, fella. You haven't lost a hand since you got the deal. What's the secret of your success?"
"Prayer."

—poker player Macon (Donnelly Rhodes) and the Sundance Kid (Robert Redford)

"Boy, I've got vision, and the rest of the world wears bifocals."

—Butch Cassidy (Paul Newman) to the Sundance Kid (Robert Redford)

Opposite: Fur trader Boone (Dewey Martin) fights with a Sioux warrior (bit player) in *The Big Sky,* based on the novel by A. B. Guthrie Jr. Director Howard Hawks also made the classic *Red River.*

"Your times is over and you're gonna die bloody. And all you can do is choose where."

—Sheriff Bledsoe (Jeff Corey) to Butch Cassidy (Paul Newman) and the Sundance Kid (Robert Redford)

"I'm 26 and I'm single and a schoolteacher, and that's the bottom of the pit. And the only excitement I've known is here with me now. So I'll go with you and I won't whine and I'll sew your socks and I'll stitch you when you're wounded and I'll do anything you ask of me—except one thing. I won't watch you die. I'll miss that scene if you don't mind."

—Etta Place (Katharine Ross) to Butch Cassidy (Paul Newman) and the Sundance Kid (Robert Redford)

"He'll feel a whole lot better after he's robbed a couple of banks."

—Butch Cassidy (Paul Newman) to Etta Place (Katharine Ross) about the Sundance Kid (Robert Redford)

Calamity Jane • 1953

"She's lovely. Charming figure. Everything a woman ought to be."
"Looks like fat-frilled, upside, undressed beef to me."

—Wild Bill Hickok (Howard Keel) and Calamity Jane (Doris Day) about actress Adelaide Adams

"It called for some mighty rapid shooting. Why, my gun got so hot I had to sit with my legs stretched out holding the muzzle of my gun between my feet to keep it from curling up on me!"

—Calamity Jane (Doris Day) to men in a bar

Cat Ballou • 1965

"Mrs. Parker didn't introduce us. I'm Catherine Ballou."
"I'm drunker than a skunk."

—young Cat Ballou (Jane Fonda) and rustler Clay Boone disguised as a priest (Michael Callan)

"He's a murderer. A hired killer. His nose was bit off in a fight."
"If I was going to be scared, I'd be scared of the fellow who bit it off, not him!"

—Jackson Two-Bears (Tom Nardini) and Frankie Ballou (John Marley) talking about Kid Shelleen (Lee Marvin)

"We're rustlers, not train robbers!"
"Why, if people didn't try something new, there'd be hardly no progress at all!"

—cattle rustler Clay Boone (Michael Callan) and would-be outlaw Cat Ballou (Jane Fonda) at the famous Hole-in-the-Wall hideout

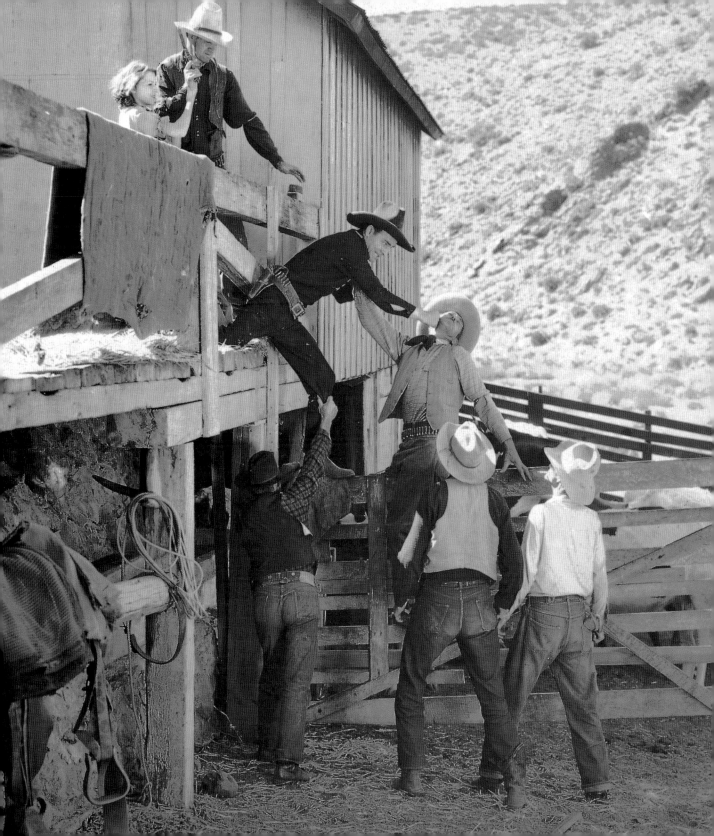

Cattle Queen of Montana

1954

"When that girl gets an idea, she's just as
stubborn as a mule with a broken hind
leg."
—old-timer Nat (Chubby Johnson) about rancher Sierra
Nevada Jones (Barbara Stanwyck)

"We're as down, broke, and defeated as
we're ever going to be. And we're on
our way back up, starting right now."
—rancher Sierra Nevada Jones (Barbara Stanwyck) to
old-timer Nat (Chubby Johnson)

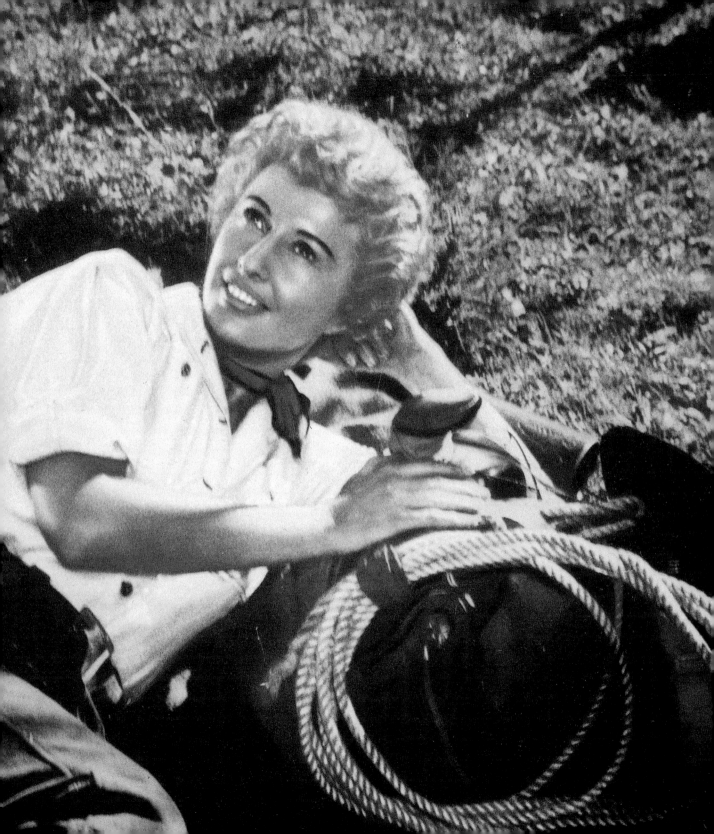

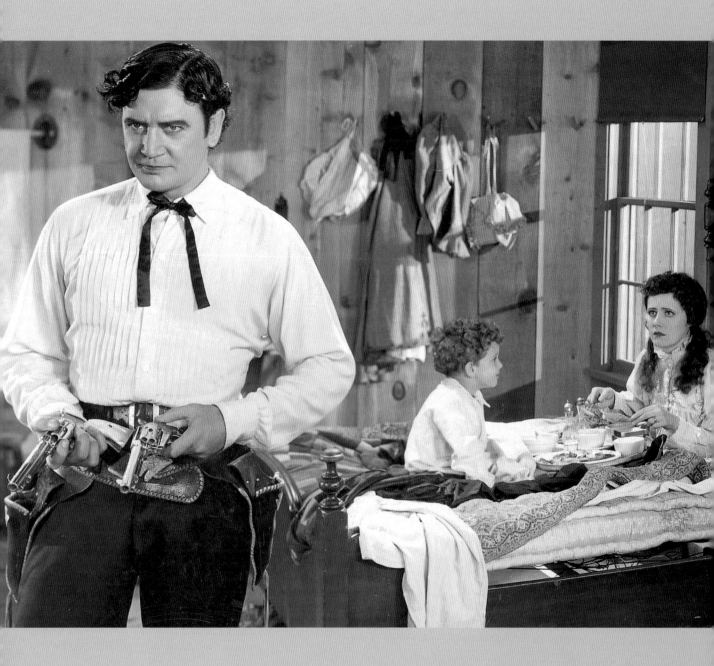

Cheyenne Autumn·1964

"Little Wolf, what happened today changes nothing. The Indian Bureau is still pledged to provide you with adequate clothing and rations. You're still pledged to abide by the law. Remember that."

"We are asked to remember much. The white man remembers nothing."

—Capt. Thomas Archer (Richard Widmark) and Cheyenne leader Little Wolf (Ricardo Montalban)

Cimarron·1931

"We've had enough of this Wichita. We're going out to a brand-new two-fisted, rip-snorting country full of Indians, rattlesnakes, gun toters and desperados. Whoopee!"

—Yancey Cravat (Richard Dix) to his shocked family

"Did you have to kill him like that?"

"No, I could have let him kill me."

—Sabra Cravat (Irene Dunne) and her husband Yancey (Richard Dix)

"Why did you let her keep your land?"

"If it was a man, I could have shot him. Can't shoot a woman."

—Felice Venable (Nance O'Neil) and Yancey Cravat (Richard Dix)

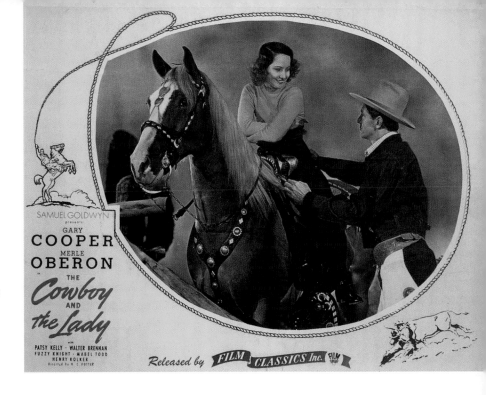

The Cowboy and the Lady·1938

"Do you think I'm a cold fish?"

"You don't exactly sizzle, Miss."

—eastern lady Mary Smith (Merle Oberon) and her maid Katie Callahan (Patsy Kelly)

Dangers of the Canadian Mounted·1948

"What's it all about?"

"The less you know, the less trouble you'll get into."

—thug (bit player) to crook Mort Fowler (Anthony Warde)

Opposite: Yancey Cravat (Richard Dix) puts on his guns while his wife, Sabra (Irene Dunne), and child look on. A sweeping epic, *Cimarron* was the first western to win an Academy Award for best picture in 1930.

Above: Rodeo cowboy Stretch Willoughby (Gary Cooper) falls in love with socialite Mary Smith (Merle Oberon) in *The Cowboy and the Lady,* a romantic comedy western.

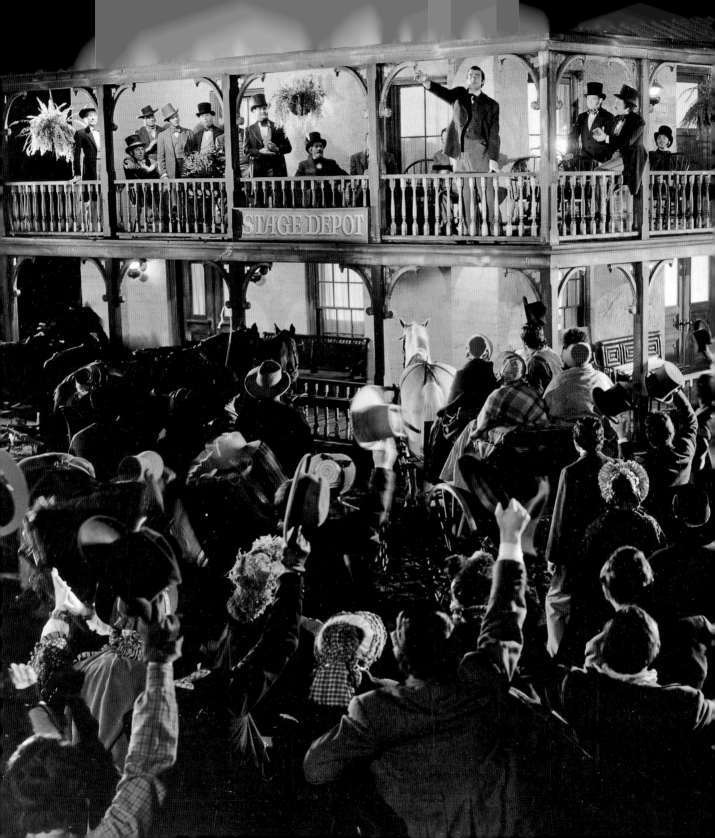

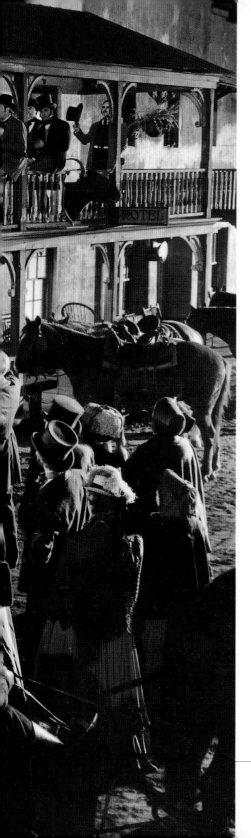

The Dark Command • 1940

"If I go out on the range, what's the
 first thing they're going to ask me?"
"For chawin' tobacco, most likely."
—young Fletch McCloud (Roy Rogers) and cowboy Bob
Seton (John Wayne)

"Ever hear what William Shakespeare
 said? 'All's well that end's well.' "
"Shakespeare, huh? He must have
 come from Texas. We've been
 saying that for years."
—young Fletch McCloud (Roy Rogers) and cowboy Bob
Seton (John Wayne)

Decision at Sundown • 1957

"Is he a big man in Sundown?"
"The biggest. He's got that town in his
 fist, and he's squeezing it hard."
—Bart Allison (Randolph Scott) and his sidekick Sam (Noah
Beery Jr.) about town boss Tate Kimbrough (John Carroll)

"If you'd been tending bar as long as I
have, you wouldn't expect so much
out of the human race."
—bartender Otis (James Westerfield) to Doctor Storrow
(John Archer)

Opposite: Running for sheriff, the
crooked William Cantrell (Walter
Pidgeon) trys to sway a crowd of
voters but is defeated by cowboy
Bob Seton (John Wayne), who is
also his rival for the love of Mary
McCloud (Claire Trevor) in *The
Dark Command.*

The Deadly Companions • 1961

"I sure hope this town has some
 pretty girls in it."
"You get this far out in the brush,
 they're all pretty."

—outlaws Parson (Strother Martin) and Yellowleg
(Brian Keith)

Destry Rides Again • 1939

"You'd better mind your own business
 or you're heading for trouble."
"Trouble is my business."

—saloon singer Frenchie (Marlene Dietrich) and Sheriff
Tom Destry (James Stewart)

"Wait a minute, lady!"
"Who're you calling a lady!"

—Sheriff Tom Destry (James Stewart) and saloon singer
Frenchie (Marlene Dietrich)

Above: Feeling guilty for accidentally
killing the son of dance hall girl Kit
Tilden (Maureen O'Hara), gunman
Yellowleg (Brian Keith) escorts her
and the boy's body home through
dangerous territory in *The Deadly
Companions.*
Opposite: Gunslinger Yellowleg
(Brian Keith) finally gets his revenge
on the psychopathic outlaw Turk
(Chill Wills) who nearly killed him
during the Civil War in *The
Deadly Companions,* director
Sam Peckinpah's first film.

"We're rich!"

"I'll get my gal's teeth plugged with diamonds and just sit and watch her smile."

—saloon singer Frenchie (Marlene Dietrich) and crooked henchman Gyp Watson (Allen Jenkins)

"What'd you say?"

"You heard me."

"That's what I thought you said."

—respectable housewife Mrs. Lily Belle Callahan (Una Merkel) and saloon singer Frenchie (Marlene Dietrich)

"I'd like to make a dress for her. Half tar, half feathers!"

—Mrs. Lily Belle Callahan (Una Merkel) about saloon singer Frenchie (Marlene Dietrich)

Dodge City • 1939

"So this is Dodge City, huh? Sort of smells like Fort Worth, don't it?"

"Oh, that's not the city you smell. That's you. We'd better get you to a bathtub before somebody shoots you for a buffalo."

—cowboy Rusty Hart (Alan Hale) and trail boss Wade Hatton (Errol Flynn)

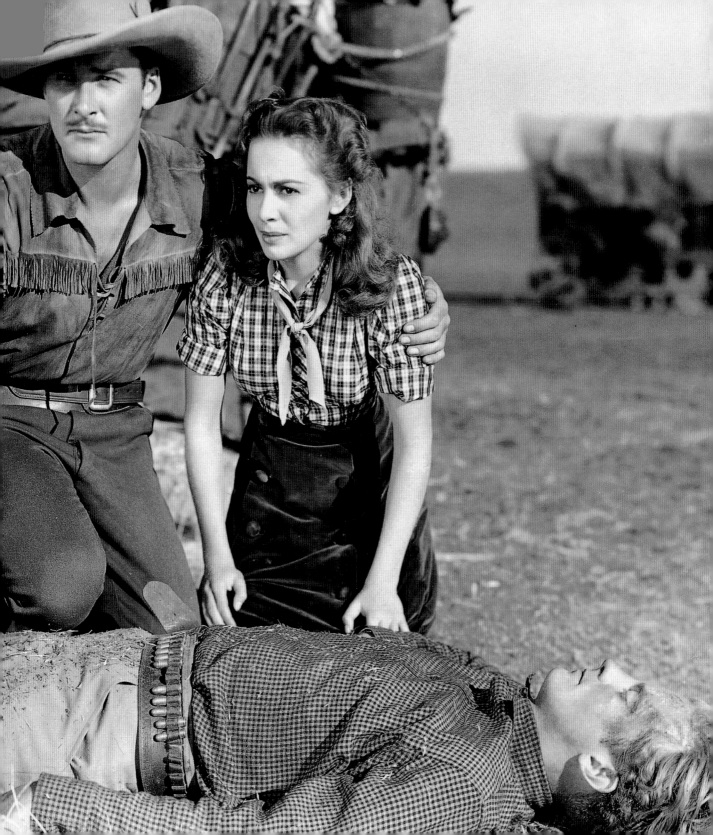

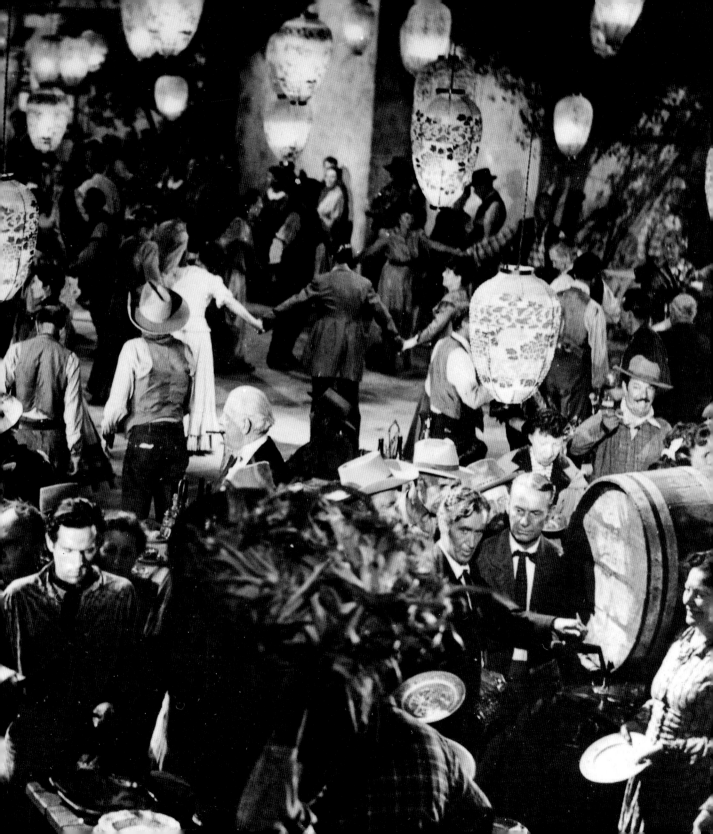

"Well, what's the news in Dodge?"

"Well, just about the same as always. Gambling and drinking and killing. Mostly killing."

—trail boss Wade Hatton (Errol Flynn) and barber Charlie (bit player)

"They sure make a fellow feel at home around here."

"They'll even dig you a home if you're nice to them."

—cowboy Rusty Hart (Alan Hale) and trail boss Wade Hatton (Errol Flynn)

The Duel at Silver Creek•1952

"You know, I've seen fancy dressers like her before. They can do more harm to a man sometimes than a pair of six-shooters."

—the Silver Kid (Audie Murphy) to Dusty Fargo (Susan Cabot)

"Dusty, you got no right to call that lady a filly."

"Seems to me she's got no right to call that filly a lady."

—Dusty's father Pete (bit player) and the Silver Kid (Audie Murphy) discussing a new woman in town

Duel in the Sun•1946

"Of course, he's a bit undisciplined, but perhaps that's what gives Westerners their charm."

—Laura Belle McCanles (Lillian Gish) about her wild son Lewt (Gregory Peck)

"You mean to shoot down unarmed men?"

"Just like they was rattlesnakes."

—good son Jesse McCanles (Joseph Cotten) and his father Senator Jackson McCanles (Lionel Barrymore)

"El Paso and Amarillo ain't no better than Sodom and Gomorrah. On a smaller scale, of course."

—preacher man Jubal Crabby (Walter Huston) to assembled party guests

"Cattle rustlers and women rustlers. They'll both steal what's got another man's brand on it."

—Lewt McCanles (Gregory Peck) to rival cattleman Sam Pierce (Charles Bickford)

El Dorado•1967

"Faith can move mountains. But it can't beat a faster draw."
—gunslinger Nels McLoud (Christopher George) to his trigger-happy gang

"Next time you shoot somebody, don't go near them till you're sure they're dead."
—the not-dead Cole Thornton (John Wayne) holding a gun on Josephine "Joey" McDonald (Michelle Carey)

"Well, if you're going to stay around here, I got two pieces of advice for you. Get rid of that hat and learn how to use a gun."
—gunfighter Cole Thornton (John Wayne) to knife-throwing Mississippi (James Caan)

"What are you doing here?"
"I'm looking at a tin star with a drunk pinned on it."
—drunken Sheriff J. P. Hara (Robert Mitchum) and his old friend, gunfighter Cole Thornton (John Wayne)

A Fistful of Dollars•1964

"If you want any work looking like that, you could try being a scarecrow."
—thug (bit player) to "The Man with No Name" (Clint Eastwood)

"You don't admire peace?"
"It's not real easy to like something you know nothing about."
—gang leader Ramon Rojo (Gian Maria Volonte) and "The Man with No Name" (Clint Eastwood)

"Our orders are to be sure he does not die. Also, make sure he regrets the day he was born."
—thug Chico (Richard Stuyvesant) about his prisoner "The Man with No Name" (Clint Eastwood)

Flaming Star•1960

"I've been killed already. I'm just stubborn about dying."
—half-Indian Pacer Burton (Elvis Presley) to his step-brother Clint (Steve Forrest)

"If shooting starts, I'll live long enough to kill you."
—Clint Burton (Steve Forrest) to Dred Pierce (Karl Swenson)

Following pages: Escape from Fort Bravo features a romantic rivalry between Yankee officer Capt. Roper (William Holden) and his rebel prisoner Capt. John Marsh (John Forsythe) for the love of southern belle Carla Forrester (Eleanor Parker).

Escape from Fort Bravo

1953

"This is a hard country to stay alive in, Colonel, much less stay young."
—Capt. Roper (William Holden) to Col. Owens (Carl Benton Reid)

"How'd a decrepit old man like you ever get in the war?"
"Because all the smart young men like you were losing it."
—soldiers Cabot Young (William Campbell) and Campbell (William Demarest)

"The women always look beautiful when they get married, and the men always look scared."
"They both get over it."
—southern belle Carla Forrester (Eleanor Parker) and Capt. Roper (William Holden)

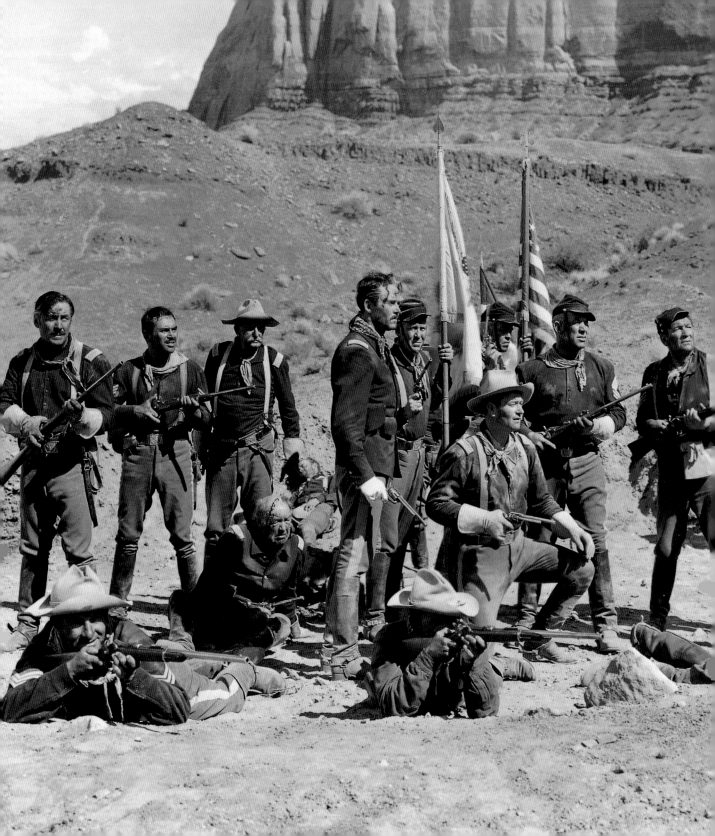

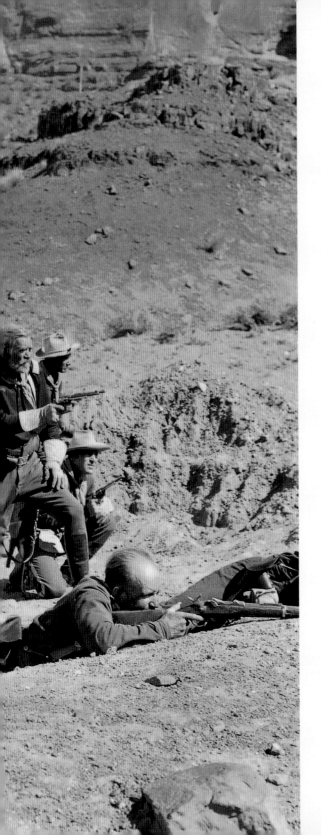

Fort Apache

1948

"What a country. Forty miles from mud
hole to mud hole."
—Lt. Col. Owen Thursday (Henry Fonda) to his daughter
Philadelphia Thursday (Shirley Temple)

"Mr. Meechum, you're a blackguard, a
liar, a hypocrite, and a stench in the
nostrils of honest men."
—Lt. Col. Owen Thursday (Henry Fonda) to corrupt Indian
Agent Meacham (Grant Withers)

"If you can see them, they're not
Apaches."
—Capt. Kirby York (John Wayne)

SAMUEL FULLER'S

FORTY GUNS

STARRING
BARBARA STANWYCK · BARRY SULLIVAN

CO-STARRING
DEAN JAGGER · JOHN ERICSON · GENE BARRY

CinemaScope

A GLOBE ENTERPRISES PRODUCTION
RELEASED BY 20th CENTURY-FOX

WRITTEN,
PRODUCED
and
DIRECTED BY Samuel Fuller

Forty Guns•1957

"What's the matter? You look upset."

"I was born upset."

—gunfighter Griff Bonnell (Barry Sullivan) and cattle queen Jessica Drummond (Barbara Stanwyck)

"I don't kill for hire."

"I'm sure you don't kill for fun."

—gunman Griff Bonnell (Barry Sullivan) and cattle queen Jessica Drummond (Barbara Stanwyck)

"I was bit by a rattler there when I was fifteen."

"Bet that rattler died."

—cattle queen Jessica Drummond (Barbara Stanwyck) and gunman Griff Bonnell (Barry Sullivan)

"You don't want the only evidence of your life's work to be bullet holes in men."

—cattle queen Jessica Drummond (Barbara Stanwyck) to gunman Griff Bonnell (Barry Sullivan)

Frontier Gal•1945

"There are only two professions open to women these days. Hers and yours. Hers is respectable."

—woman (bit player) to saloon girl Lorena Dumont (Yvonne De Carlo)

Giant•1956

"I wouldn't do that if I were you."

"You ain't."

—Leslie Benedict (Elizabeth Taylor) and bad boy Jett Rink (James Dean)

"A gusher come in first year."

"How wonderful."

"Right now it's bringing in a million."

"A million gallons?"

"Dollars."

"A million dollars a year? That's wonderful."

"A million dollars a month."

—Texas millionaire (bit player) and newly arrived bride Leslie Benedict (Elizabeth Taylor)

"You're a Texan, now."

"Is that a state of mind?"

—rancher Bick Benedict (Rock Hudson) and his wife Leslie (Elizabeth Taylor)

"Money isn't all, you know, Jett."

"Not when you got it."

—Leslie Benedict (Elizabeth Taylor) and bad boy Jett Rink (James Dean)

"Bick, you should have shot that fellow a long time ago. Now he's too rich to kill."

—Judge Bawley Benedict (Chill Wills) to Bick Benedict (Rock Hudson) about newly oil rich Jett Rink (James Dean)

Preceding pages: Fort Apache, the first in director John Ford's cavalry trilogy, features a clash between a by-the-book officer Lt. Col. Owen (Henry Fonda) and the experienced Capt. Kirby York (John Wayne).

Opposite: The brutal and violent cult favorite *Forty Guns* was written and directed by Samuel Fuller, who was noted for his often corrupt and amoral characters. Fuller's work inspired the spaghetti westerns of Sergio Leone.

Goin' to Town•1935

"For a long time I was ashamed of the way I lived."

"You mean to say you reformed?"

"No, I got over being ashamed."

—cowboy (bit player) and dance hall girl Cleo Borden (Mae West)

"When it comes to you, I'm dynamite."

"Yeah, and I'm your match."

—rancher Buck Gonzales (Fred Kohler) and dance hall girl Cleo Borden (Mae West)

The Good, the Bad and the Ugly•1966

"Big fat men like you, when they fall, they make more noise. And sometimes they never get up."

—Mexican desperado Tuco (Eli Wallach) to prison guard Wallace (bit player)

"Put your drawers on and take your gun off."

—"The Man with No Name" (Clint Eastwood) to the naked but armed Mexican bandit Tuco (Eli Wallach)

"There are two kinds of people in this world—those with pistols and those who dig. You dig."

—"The Man with No Name" (Clint Eastwood) to Mexican bandit Tuco (Eli Wallach)

Gunfight at the O.K. Corral•1957

"You think you're pretty tough, don't you, son? I never saw a gunfighter so tough he lived to see his thirtieth birthday."

—Marshal Wyatt Earp (Burt Lancaster) to young outlaw Billy Clanton (Dennis Hopper)

"All gunfighters are lonely. They live in fear, they die without a dime, a woman, or a friend."

—Marshal Wyatt Earp (Burt Lancaster) to young outlaw Billy Clanton (Dennis Hopper)

The Gunfighter•1950

"He don't look so tough to me."

"If he ain't so tough, there's been an awful lot of sudden natural deaths in his vicinity."

—young tough Eddie (Richard Jaeckel) and cowboy (bit player)

"Looks like everybody's drawing behind your back these days."

"All the smart ones."

—Hunt Bromley (Skip Homeier) to Deputy Charlie (Anthony Ross)

Opposite: In Fort Worth, *gunfighter turned newspaper editor Ned Britt (Randolph Scott) has to take up his gun again to fight outlaws who want to stop him from printing the truth.*

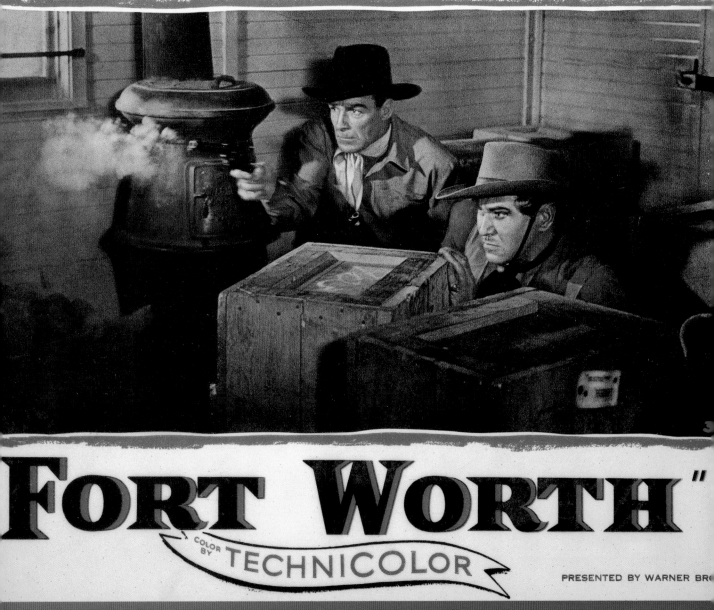

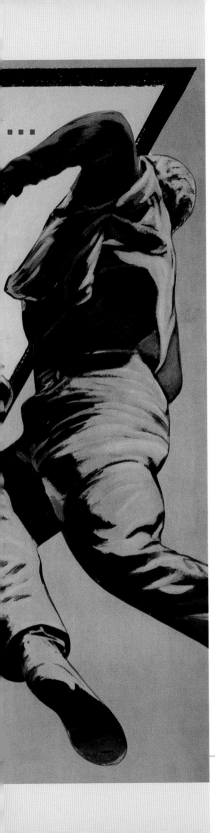

Gun Fury•1953

"She's as different from other women
 as cognac is from corn liquor."
"You get the same kind of headache
 from either one."
—outlaw Frank Slayton (Philip Carey) and his henchman
Jess Burgess (Leo Gordon)

"I almost got married once myself. It
was all set until her family came West
in a covered wagon. If you'd've seen
her family, you'd know why the wagon
was covered."
—stagecoach passenger Mr. Weatherby (bit player) to
young bride-to-be Jenny Ballard (Donna Reed)

"A man's gotta do his own growin' no
matter how tall his father was."
—cattleman Ben Warren (Rock Hudson) to reformed
outlaw Jess Burgess (Leo Gordon)

"Sooner or later, I kill you."
"Let's make it later."
—Estella Morales (Roberta Haynes) and outlaw Blinky
(Lee Marvin)

The Halliday Brand•1957

"Maybe a few innocent men did get
killed. But I got things done."
—rancher/sheriff Big Dan Halliday (Ward Bond) to his
son Daniel (Joseph Cotten)

Opposite: The Halliday Brand is a
bitter and brutal portrayal of the
consequences of patriarchy and
racism. Director Joseph H. Lewis
was rediscovered in the 1960s by
both French and American critics
and hailed as a genuine "auteur."

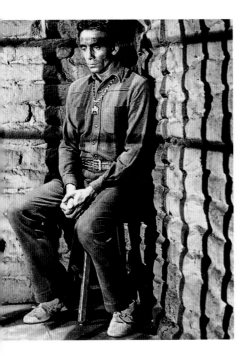

Hang 'em High • 1967

"Some people call this hell. But you're still in Oklahoma Territory."

—Deputy Marshal Dave Bliss (Ben Johnson) to his prisoner Jed Cooper (Clint Eastwood)

"You'll get used to the smell."

"If you don't, they got a sure cure for it. They hang you."

—prison warden and prisoner (bit players) to new inmate Jed Cooper (Clint Eastwood)

"If the hanging didn't kill you, maybe my coffee will."

—hanging Judge Fenton (Pat Hingle) to freed prisoner Jed Cooper (Clint Eastwood)

"Go to hell."

"I've already been there."

—hanging Judge Fenton (Pat Hingle) and Jed Cooper (Clint Eastwood)

The Hanging Tree • 1959

"Every new mining camp's gotta have its Hanging Tree. Makes folks feel respectable."

—miner (bit player) to his wife (bit player)

"If you ain't the devil, well he's sure sitting on your shoulder."

—Rune (Ben Piazza) to Doc Joe Frail (Gary Cooper)

Heller in Pink Tights • 1960

"Pretty country, ain't it?"

"Don't it ever end?"

—hired gun Clint Mabry (Steve Forrest) and actress Lorna Hathaway (Eileen Heckert)

"I ain't a man to look for trouble, but I don't run from it."

—hired gun Clint Mabry (Steve Forrest) to actor/manager Tom Healy (Anthony Quinn)

High Noon • 1952

"It takes more than big broad shoulders to make a man, Harvey. And you have a long way to go. You know something? I don't think you will ever make it."

—widow Helen Ramirez (Katy Jurado) to Deputy Harvey Tell (Lloyd Bridges)

"You've been a lawman all your life."

"Yeah, yeah. All my life. It's a great life. You risk your skin catching killers and then juries turn them loose so they can come back and shoot at you again. If you're honest, you're poor your whole life. And in the end you wind up dying all alone on some dirty street. For what? For nothing. For a tin star."

—townsman Martin Howe (Lon Chaney Jr.) and Marshal Will Kane (Gary Cooper)

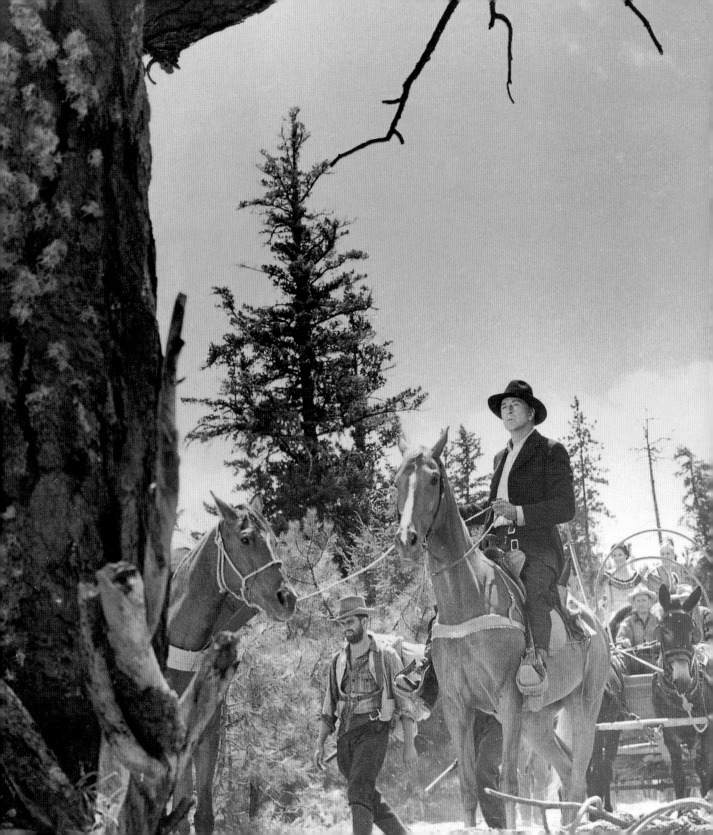

"Stay at the hotel until it's over."

"No. I won't be here when it's over. You're asking me to wait an hour to find out if I'm going to be a wife or a widow. I say it's too long to wait. I won't do it."

——Marshal Will Kane (Gary Cooper) and his new wife Amy (Grace Kelly)

"I thought you'd growed up by now."

"I thought your disposition might have sweetened down in Abilene. I guess we're both wrong."

——outlaws James Pierce (Robert J. Wilke) and Ben Miller (Sheb Wooley)

Hombre•1967

"What are you doing here?"

"Going bad, honey."

——landlady Jessie (Diane Cilento) and outlaw Frank Braden (Cameron Mitchell)

"Any time a man weasels out on you, turns out that he's doing you a favor."

——landlady Jessie (Diane Cilento)

"And if you want to know if I'm carrying a gun, I'm not. My tongue is my only weapon, Mr. Grimes."

"And it's deadly."

——landlady Jessie (Diane Cilento) to outlaw Cicero Grimes (Richard Boone)

Hondo•1953

"Well, everyone needs someone."

"Yes, Ma'am. Most everybody. Too bad, isn't it?"

——homesteader Angie Lowe (Geraldine Page) and army scout Hondo Lane (John Wayne)

"What'd you hit me for?"

" 'Cause I know you."

——Hondo Lane (John Wayne) and Buffalo Baker (Ward Bond)

"I love you. I suppose I shouldn't have said that, with my husband dead so short a time."

"I don't guess people's hearts got anything to do with it."

——Angie Lowe (Geraldine Page) and Hondo Lane (John Wayne)

How the West Was Won • 1962

"Thank you, ma'am, that was right
 tasty."
"You've only et four plates. I was
 beginning to think you didn't like it."
"Well, it doesn't pay to eat too much
 on an empty stomach, ma'am."
—Linus Rawlings (James Stewart) and Rebecca Prescott
(Agnes Moorehead)

"You make me feel like a man standing
on a narrow ledge face to face with a
grizzly bear. There just ain't no
ignoring the situation."
—Linus Rawlings (James Stewart) to Eve Prescott
(Carroll Baker)

"Why, for you, child-bearing would
 come as easy as rolling off a log."
"Well, I think I'd rather roll off a log,
 Mr. Morgan."
—wagon train leader Roger Morgan (Robert Preston) and
Lilith Prescott (Debbie Reynolds)

Hud • 1963

"Happens to everybody. Horses, dogs,
and men. Nobody gets out of life
alive."
—Hud Bannon (Paul Newman) to his nephew Lon
(Brandon De Wilde)

"Old people get as hard as their
arteries sometimes."
—Homer "Wild Horse" Bannon (Melvyn Douglas) to his
grandson Lon (Brandon De Wilde)

"You don't look out for yourself, and
the only helping hand you'll ever get is
when they lower the box."
—Hud Bannon (Paul Newman) to his nephew Lon
(Brandon De Wilde)

"I always say the law was meant to be
interpreted in a lenient manner. And
that's what I try to do. Sometimes I
lean to one side of it, sometimes I lean
to the other."
—Hud Bannon (Paul Newman) to his nephew Lon
(Brandon De Wilde)

"Man like that sounds no better than a
 heel."
"Aren't you all?"
"Honey, don't go shooting all the dogs
 'cause one of them's got fleas."
—Hud Bannon (Paul Newman) trying to flirt with
housekeeper Alma (Patricia Neal)

The Indian Fighter•1955

"You're a fine woman, Susan. I only wish I had half your character."

"I've got enough for both of us."

——frontiersman Johnny Hawks (Kirk Douglas) and widow Susan Rogers (Diana Douglas)

"You can hold me tighter. I ain't made of glass."

——widow Susan Rogers (Diana Douglas) to frontiersman Johnny Hawks (Kirk Douglas)

"One man can't handle an uprising—I don't care who he is."

——Capt. Trask (Walter Able)

The Iron Sheriff•1957

"A man can't die with something on his mind."

——Eugene Walden (Stanford Jolley) to Sheriff Sam Galt (Sterling Hayden)

"It's my business to see that a man doesn't pay for something he didn't do."

——Sheriff Sam Galt (Sterling Hayden)

Jesse James•1939

"The marshal's got thirty men out looking for you, son."

"And in all this rain too."

——Maj. Rufus Cobb (Henry Hull) and Jesse James (Tyrone Power)

"We're going to try and hang our lawless friend, of course!"

"Before or after the trial?"

——prosecutor Mr. Clarke (Willard Robertson) and Marshal Will Wright (Randolph Scott)

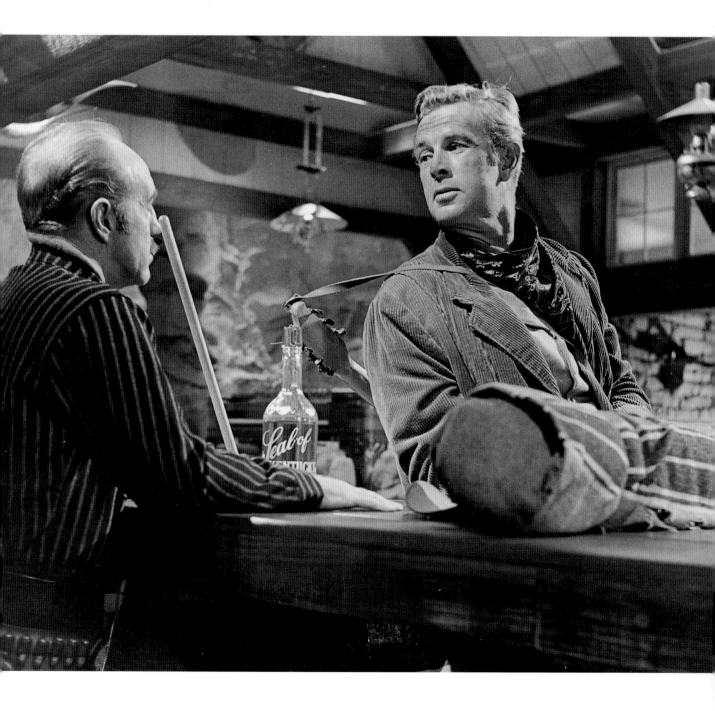

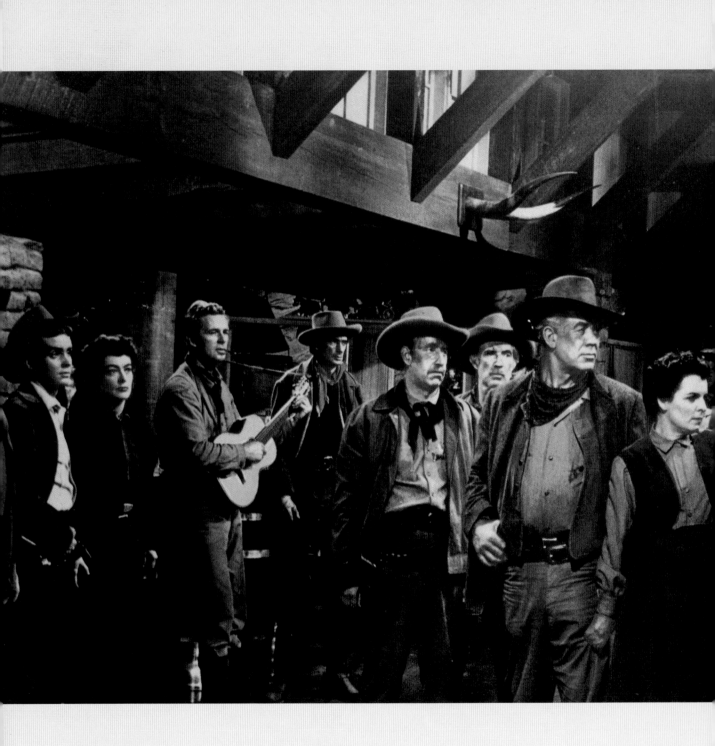

Johnny Guitar

1954

"Never seen a woman who was more like a man.
She thinks like one, acts like one, and sometimes
makes me feel like I'm not."

—casino croupier (bit player) about bar owner Vienna (Joan Crawford)

"You know, some men have a craving for gold and
silver. Others need lots of land with herds of cattle.
And there's those that got the weakness for whiskey
and for women. And you boil it all down, what does
a man really need? Just a smoke and a cup of coffee."

—Johnny Guitar (Sterling Hayden) in Vienna's bar

"A man can lie, steal, and even kill. But as long as
he hangs on to his pride, he's still a man. All a
woman has to do is slip once, and she's a tramp."

—bar owner Vienna (Joan Crawford)

"How many men have you forgot?"
"As many women as you've remembered."

—Johnny Guitar (Sterling Hayden) and bar owner Vienna (Joan Crawford)

"Boys who play with guns have to be ready to die like men."

—bar owner Vienna (Joan Crawford)

Opposite: Charming adventurer Dan Kehoe (Clark Gable) finds out from a monk (bit player) that he's been double-crossed in his plan to nab a stolen fortune from under the nose of crafty outlaw matriarch Ma McDade (Jo Van Fleet) in director Raoul Walsh's comedy western, *The King and Four Queens.*

Jubal • 1955

"You ride good?"

"I can stay on most of them."

—rancher Shep Hogan (Ernest Borgnine) and drifter Jubal Troop (Glenn Ford)

"Hey, you fellas. Move any slower and you're going to be doing yesterday's work."

—rancher Shep Hogan (Ernest Borgnine) to his cowhands

"I like my coffee strong enough to float a pistol."

—rancher Shep Hogan (Ernest Borgnine) to drifter Jubal Troop (Glenn Ford)

Kansas Pacific • 1953

"Are you going to drink that coffee, or are you just going to stir it until it evaporates?"

—railway builder Cal Bruce (Baron McClane) to his daughter Barbara (Eve Miller)

"Any trouble?"

"Yeah, with the sheriff. They'll need a new one now."

—Quantrill (Reed Hadley), leader of Quantrill's Raiders, and his gang

The Kentuckian • 1955

"You coming peaceable?"

"I ain't comin' at all."

—sheriff (bit player) and frontiersman Eli Wakefield (Burt Lancaster)

"My mammy was a 'gator and my pappy was a bull. I can whup my weight in wildcats and drink my belly full."

—town drunk (bit player)

"We're going to Texas. We're going to live it bold!"

—frontiersman Eli Wakefield (Burt Lancaster) to his true love Hannah (Dianne Foster)

The King and Four Queens • 1956

"Man rides like that'll kill himself."

"Save us the trouble."

—two outlaws (bit players) about adventurer Dan Kehoe (Clark Gable)

"Judging from the scars I counted on you, you have plenty of enemies. You must have at least one friend."

—Sabina McDade (Eleanor Parker) to adventurer Dan Kehoe (Clark Gable)

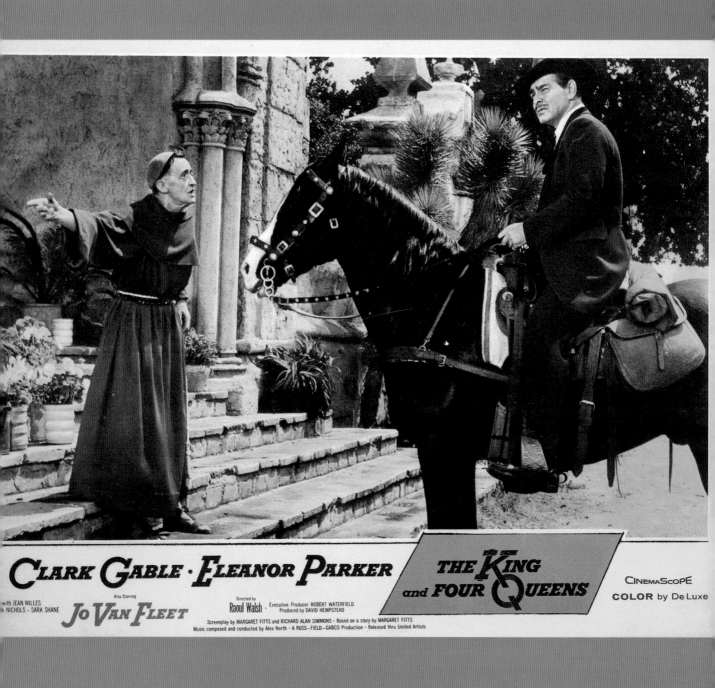

CLARK GABLE · ELEANOR PARKER

with JEAN WILLES
NICHOLS · SARA SHANE

Also Starring

JO VAN FLEET

Directed by
Raoul Walsh · Executive Producer ROBERT WATERFIELD
Produced by DAVID HEMPSTEAD

Screenplay by MARGARET FITTS and RICHARD ALAN SIMMONS · Based on a story by MARGARET FITTS
Music composed and conducted by Alex North · A RUSS—FIELD—GABCO Production · Released thru United Artists

THE KING and FOUR QUEENS

CINEMASCOPE
COLOR by De Luxe

"I wouldn't trust you with a snowball in a blizzard."

—Sabina McDade (Eleanor Parker) to Dan Kehoe (Clark Gable)

"You're a woman after my own heart. Tougher than wagon leather, smarter than spit, and colder than January."

—Dan Kehoe (Clark Gable) to Sabina McDade (Eleanor Parker)

Lady from Cheyenne • 1941

"What's the fight about?"
"I don't know—let's get in it!"

—two bit players

"There's a lump in the mattress, but you'll find you can curl around it. Just experiment and don't go calling me and complaining. The rent's always in advance every Monday, and we got one strict rule—no singing after two o'clock in the morning."

—landlady (bit player) to schoolmarm Ann Morgan (Loretta Young)

"I'll run that schoolmarm out of this town so fast she'll think she's been shot out of a .45. And all the rest of them that wants votes for women."

—Jim Cork (Edward Arnold)

The Last of the Fast Guns • 1958

"You wanted to see me?"
"I wanted to see the winner."
"Nobody wins in a gunfight."

—gunfighter Brad Ellison (Jock Mahoney) and John Forbes (Carl Benton Reid)

"I've met a lot of men in my time. A woman they forget, a mine busting with gold, even the faces of their own children. But I've never met a man who forgot a grave he dug."

—gunfighter Brad Ellison (Jock Mahoney)

The Last Sunset • 1961

"Cowboys aren't very bright. They're always broke and generally they're drunk."

—drifter Bren O'Malley (Kirk Douglas) to Missy Breckenridge (Carol Lynley)

"There's someone on my tail, sure. There always is. But I haven't been running from him, I've just been coming to you."

—drifter Bren O'Malley (Kirk Douglas) to Belle Breckenridge (Dorothy Malone)

Last Train from Gun Hill • 1959

"I told you to leave town. Are you tired of living, or just plain crazy?"

—rancher Craig Belden (Anthony Quinn) to Marshal Matt Morgan (Kirk Douglas)

"You know something? Forty years from now, the weeds will grow just as pretty on my grave as they will on yours. And nobody will even remember that I was yellow and that you died like a fool."

—corrupt Sheriff Bartlett (Walter Sande) to Marshal Matt Morgan (Kirk Douglas)

"Isn't there anybody in this town who's not afraid of Craig Belden?"
"Sure. The graveyard's full of them."

—Marshal Matt Morgan (Kirk Douglas) and bartender (Val Avery)

"Who'd ever think that you'd turn out to be a marshal?"
"Finally figured out the other side didn't pay."

—rancher Craig Belden (Anthony Quinn) and Marshal Matt Morgan (Kirk Douglas)

"You! You're breaking the law!"
"I *am* the law!"

—hotel clerk (William Newell) and Marshal Matt Morgan (Kirk Douglas)

The Left-Handed Gun • 1958

"Looks like you've got nine lives."
"I've got eight left."

—Pat Garrett (John Dehner) and Billy the Kid (Paul Newman)

Little Big Man • 1970

"That was the end of my religion period. I ain't sung a hymn in 104 years."

—old-timer Jack Crabb (Dustin Hoffman)

"Am I still in this world?"
"Yes, Grandfather."
"I was afraid of that. Well, sometimes the magic works, sometimes it doesn't."

—Old Lodge Skins (Chief Dan George) to Jack Crabb (Dustin Hoffman) when he wakes up after laying himself down to die

"I have a wife. And four horses."
"I have a horse and four wives."

—Younger Bear (Cal Bellini) and Little Big Man/Jack Crabb (Dustin Hoffman)

Following pages, left: The Law and Jake Wade pits Sheriff Jake Wade (Robert Taylor) against his one-time partner, outlaw Clint Hollister (Richard Widmark). Director John Sturges has many classic westerns to his credit, including *The Magnificent Seven* and *Gunfight at the O.K. Corral*. *Following pages, right:* In *The Law and Jake Wade*, Sheriff Jake Wade (Robert Taylor) forces a lawman (bit player) to release outlaw Clint Hollister (Richard Widmark) because Wade owes Hollister a favor for saving his life long ago.

The Law
and Jake Wade

1958

"How many times have I told you—if you let your hate get the upper hand, it'll throw your timing off."

—outlaw Clint Hollister (Richard Widmark) to young outlaw Wexler (DeForest Kelley)

"Sonny, I can see we ain't going to have you 'round long enough to get tired of your company."

—outlaw Clint Hollister (Richard Widmark) to young outlaw Wexler (DeForest Kelley)

"I'm sorry, Clint, I just didn't stop to think."
"They'll chisel that on your tombstone."

—hired gun Rene (Henry Da Silva) and gang boss Clint Hollister (Richard Widmark)

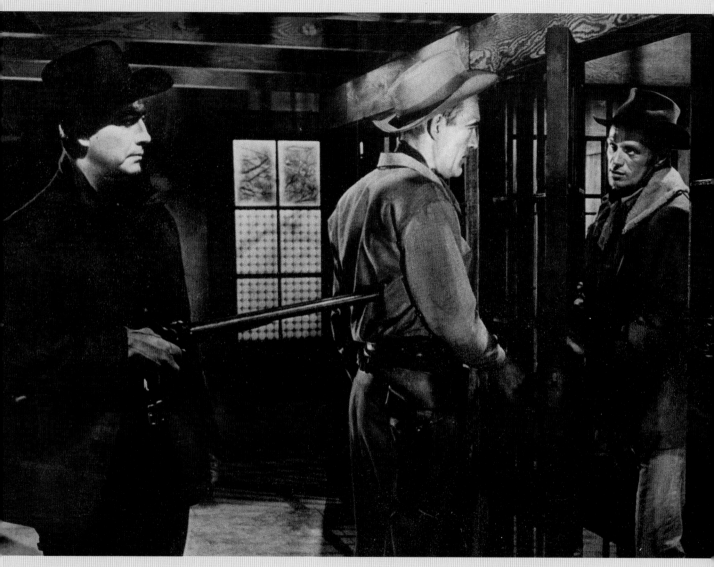

"You go ahead and kill anybody you want to—it's a free country. But if you do it with hate in your heart, you'll end up with nothing but an upset stomach."

—outlaw Clint Hollister (Richard Widmark)

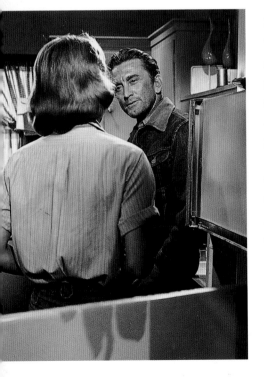

Lone Star • 1951

"Have you never heard of the word discretion, Mr. Jones?"

"Oh, often. But I don't approve of it. Do you?"

—Martha Rond (Ava Gardner) and adventurer Dev Burke in disguise (Clark Gable)

"Mr. Burke? I thought you said a smart man knows when he's whipped."

"Who says I'm smart?"

—young gun Bud Yoakum (Ralph Reed) and adventurer Dev Burke (Clark Gable)

Lonely Are the Brave • 1962

"About every six months, I feel I owe myself a good drunk. Rinses your insides out, sweetens your breath, tones up your skin."

—cowboy Jack W. Burns (Kirk Douglas) to his friend Jerri Bondi (Gena Rowlands)

"Where do you live?"

"Anywhere I feel like."

—small town police officer (bit player) and cowboy Jack W. Burns (Kirk Douglas)

"Ah, the temptations of the flesh. I fought 'em my whole life through."

"Then how come you're in here, Reverend?"

"I said I fought 'em—I didn't say I fought 'em off."

—Reverend Hoskins (Karl Swenson) and cellmate (bit player)

"Take it easy. Temper like that, and one of these days you'll find yourself riding through town with your belly in the sun, your best suit on, and no place to go but hell."

—jailed cowboy Jack W. Burns (Kirk Douglas) to sadistic prison guard (bit player)

"Believe you me, if it didn't take men to make babies, I wouldn't have anything to do with any of you."

—Jerri Bondi (Gena Rowlands) to her friend, cowboy Jack W. Burns (Kirk Douglas)

The Magnificent Seven • 1960

"Where are you headed?"

"Drifting south more or less. You?"

"Just drifting."

—gunfighter Vin (Steve McQueen) to gunfighter Chris Adams (Yul Brynner)

"Very young. Very proud."

"The graveyards are full of the very young and the very proud."

—peasant leader (bit player) and gunfighter Chris Adams (Yul Brynner) talking about young gun Chico (Horst Buchholz)

"If God hadn't meant for them to be sheared, he wouldn't have made them sheep."

—bandit Calvera (Eli Wallach) about the Mexican farmers

The Man from Laramie • 1955

"You're just a hard, scheming old woman, aren't you?"

"Ugly too."

—Will Lockhart, "The Man from Laramie" (James Stewart) and cattle queen Kate Canady (Aline MacMahon)

"You've got no cause to shoot me!"

"Shooting's too good for you."

—ranch foreman Vic Hansbro (Arthur Kennedy) and Will Lockhart, "The Man from Laramie" (James Stewart)

"It's your neck, Lockhart. If you want a Christian burial, better leave some money with the undertaker."

—Sheriff Tom Quigby (James Millican) to Will Lockhart, "The Man from Laramie" (James Stewart)

The Man from the Alamo • 1953

"Next time you go on a job, stay out of saloons."

"We only had a couple."

"A couple of gallons!"

—Jess Wade (Victor Jory) and gunmen (bit players)

Man in the Saddle • 1951

"Are you drunk yet, Owen?"

"Bottle's still about half full."

"Well then, you're sober."

—Bourke Prine (Guinn "Big Boy" Williams) and Owen Merritt (Randolph Scott)

Man in the Shadows • 1957

"Over in Europe, there aren't five or six countries as big as this ranch."

—rancher Virgil Renchler (Orson Welles) to Sheriff Ben Sadler (Jeff Chandler)

"If you want to get to town alive, get moving. You want to get there dead, just keep talking."

—Sheriff Ben Sadler (Jeff Chandler) to rancher Virgil Renchler (Orson Welles)

"You give me any more trouble, and Bingham County's gonna have a new sheriff."

—rancher Virgil Renchler (Orson Welles) to Sheriff Ben Sadler (Jeff Chandler)

The Man Who Shot Liberty Valance • 1962

"I live where I hang my hat."

—outlaw Liberty Valance (Lee Marvin) in a speech to assembled voters

"You looking for trouble, Donovan?"
"You aiming to help me find some?"

—outlaw Liberty Valance (Lee Marvin) and sworn enemy Tom Donovan (John Wayne)

"This is the West, sir. When the legend becomes fact, we print the legend."

—newspaper editor (bit player) to Senator Ransom Stoddart (James Stewart)

Man Without a Star • 1955

"Hear what we're putting in? A bathroom right in the house."
"Inside the house? Well, that ain't decent. Only someone from the East would think of that."

—ranch foreman Strap Davis (Jay C. Flippen) and cowboy Dempsey Rae (Kirk Douglas)

"You're not bad with horses."
"I'm not bad with anything."

—ranch owner Reed Bowman (Jeanne Crain) and cowboy Dempsey Rae (Kirk Douglas)

"Nobody can make a fool out of you, kid. You've got to do that yourself."

—cowboy Demspey Rae (Kirk Douglas) to youngster Jeff Jimson (William Campbell)

"How does it feel to be put in your place?"
"I wouldn't know. Why don't you try putting me there?"

—cowboy Latigo (Sheb Wooley) and cowboy Dempsey Rae (Kirk Douglas)

Many Rivers to Cross

1955

"If he asked her to bring him the Ohio River in a saucepan, she'd do it."

—Mrs. Cherne (Josephine Hutchinson) about her daughter's infatuation with trapper Bushrod Gentry (Robert Taylor)

"What's she doing with a man?"
"She probably shot him."

—Cadmus Cherne (Victor McLaglen) and his son (bit player), surprised that Mary has found a man

"I'm going to marry him."
"Well, he might have something to say about that."

—wild girl Mary Stuart Cherne (Eleanor Parker) to her mother (Josephine Hutchinson) about trapper Bushrod Gentry (Robert Taylor)

Previous pages: Frontierswoman
Mary Stuart Cheme (Eleanor
Parker) is determined to win the
heart of trapper Bushrod Gentry
(Robert Taylor) in the comedy
western *Many Rivers to Cross.*
Left: The chase is on for the famous
masked swordsman of the West in
this scene from the first version of
The Mark of Zorro (1920), starring
Douglas Fairbanks in the title role.
So far dozens of films have been
made about the popular Zorro.

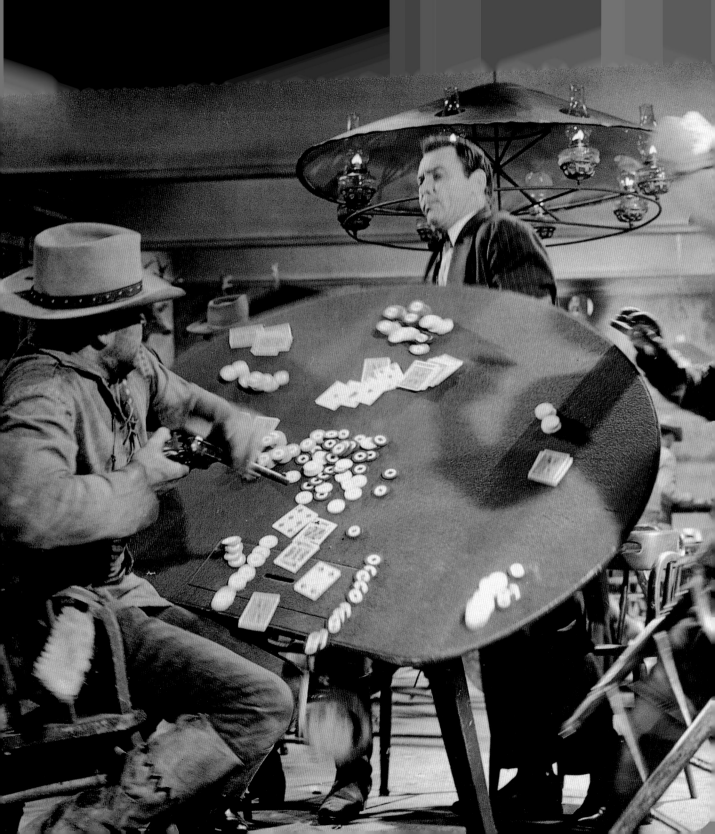

The Maverick Queen

1956

"What are you doing out here?"

"The only place left that isn't crawling with civilization."

—Kit Banyon, the Maverick Queen (Barbara Stanwyck) and undercover Pinkerton cop
Jeff Younger (Barry Sullivan)

"You can count me out. I'm no fool."

"Well, that's a matter of opinion."

—the Sundance Kid (Scott Brady) and Kit Banyon, the Maverick Queen
(Barbara Stanwyck)

"The only way you leave the Wild Bunch is feet first."

—Kit Banyon, the Maverick Queen (Barbara Stanwyck) to undercover Pinkerton cop
Jeff Younger (Barry Sullivan)

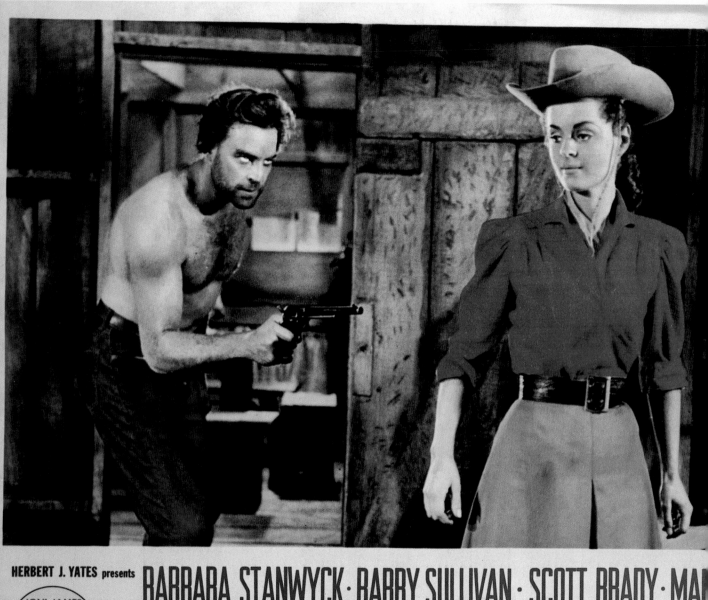

HERBERT J. YATES presents **BARBARA STANWYCK · BARRY SULLIVAN · SCOTT BRADY · MA**

JONI JAMES sings "THE MAVERICK QUEEN" by Ned Washington and Victor Young

IN **THE MAVERICK QUEE**

WITH WALLACE FORD · HOWARD PETRIE · JIM DAVIS · EMILE MEYER · WALTER SANDE · GEORGE KEYMAS · JOHN DOUC

The Misfits•1961

"He's a cowboy."

"How do you know?"

"I can smell, can't I?"

"You can't smell cows on me."

"I can smell the look on your face, cowboy, but I love every miserable one of ya. Course, you're all good for nothing, as you well know."

—Isabelle Steers (Thelma Ritter) and cowboy Gay Langland (Clark Gable)

"Cowboys are the last real men left in the world, and they're about as reliable as jackrabbits."

—Isabelle Steers (Thelma Ritter) to Roslyn Taber (Marilyn Monroe)

"Honey, we all got to go sometime, reason or no reason. Dyin's as natural as livin'. A man who's too afraid to die is too afraid to live."

—cowboy Gay Langland (Clark Gable) to Roslyn Taber (Marilyn Monroe)

Previous pages: A Pinkerton agent disguised as outlaw Jeff Younger (Barry Sullivan) breaks up a crooked card game by overturning the table in *The Maverick Queen.* He's looking for Butch Cassidy and the Sundance Kid.

Opposite: Outlaw Sundance Kid (Scott Brady) knows the law is on his trail so he takes rancher Lucy Lee (Mary Murphy) hostage in *The Maverick Queen.* The film is based on a novel by the famous western writer Zane Grey.

Following pages: Outlaw Belle Starr (Jane Russell) gets involved with the notorious Dalton gang and plans to double-cross them in director Allan Dwan's entertaining *Montana Belle.*

Montana Belle•1952

"What do you suppose they want to
 bring a woman here for?"
"There's several answers to that
 question."

—outlaws Emmett Dalton (Ray Teal) and Matt Towner
(John Litel)

"Why don't you take a bath?"
"What's the use? A man just gets dirty
 again."

—outlaw Ben Dalton (Holly Bane) and trader Pete Bivins
(Andy Devine)

Monte Walsh•1970

"You're goin' to break a leg someday
 doing that."
"I've got two."

—cowboy Chet Rollins (Jack Palance) to his sidekick
Monte Walsh (Lee Marvin) during a rambunctious roundup

"Cowboys don't get married unless
they stop being cowboys."

—cowboy Monte Walsh (Lee Marvin) to his lover Martine
Bernard (Jeanne Moreau)

"I've heard a lot about you, and not all
of it bad, either."

—Wild West show promoter Col. Wilson (Eric Christmas)
to cowboy Monte Walsh (Lee Marvin)

68

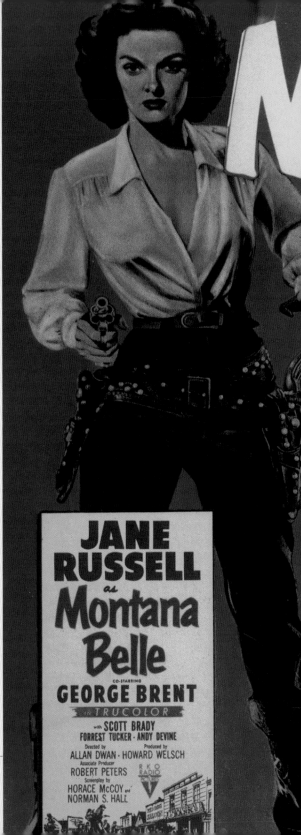

JANE
RUSSELL
as
Montana
Belle
CO-STARRING
GEORGE BRENT
IN TRUCOLOR
with SCOTT BRADY
FORREST TUCKER · ANDY DEVINE
Directed by
ALLAN DWAN · HOWARD WELSCH
Associate Producer Produced by
ROBERT PETERS RKO RADIO
Screenplay by
HORACE McCOY and
NORMAN S. HALL

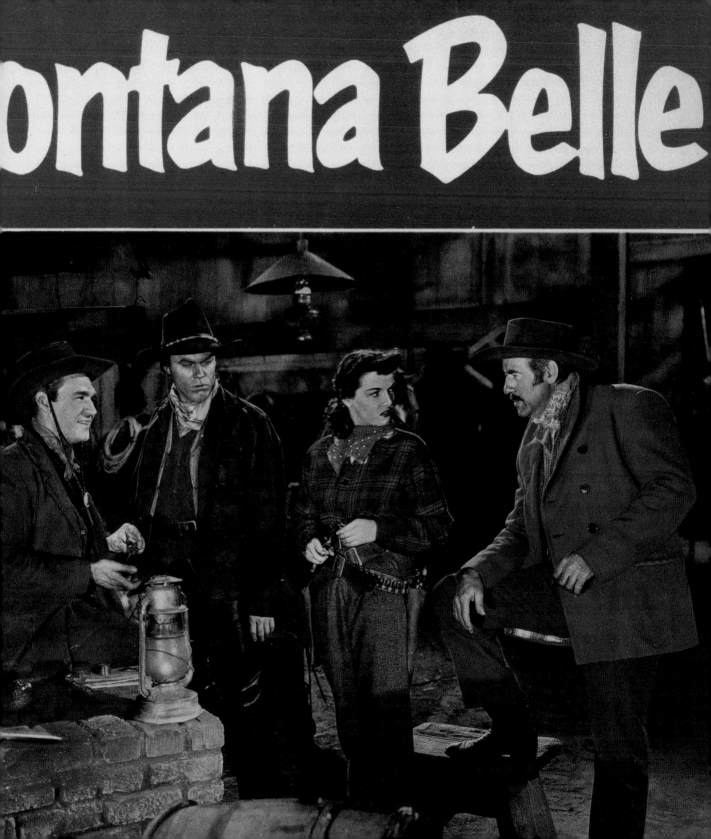

My Darling Clementine • 1946

"Mack, you ever been in love?"

"No, I been a bartender all my life."

—Wyatt Earp (Henry Fonda) and bartender (J. Farrell MacDonald)

My Little Chickadee • 1940

"Mmmm, funny, every man I meet wants to protect me. I can't figure out what from."

—Flower Belle Lee (Mae West)

"Uh, is this a game of chance?"

"Not the way I play it, no."

—Cousin Zeb (Fuzzy Knight) and con man Cuthbert J. Twillie (W. C. Fields)

"If a thing is worth having, it's worth cheating for."

—con man Cuthbert J. Twillie (W. C. Fields)

"Any time you got nothing to do and lots of time to do it, come up."

—Flower Belle Lee (Mae West)

"I hope that wasn't whiskey you were drinking."

"Ah, no, dear, just a little sheep dip. Panacea for all stomach ailments."

—Mrs. Gideon (Margaret Hamilton) and con man Cuthbert J. Twillie (W. C. Fields)

The Naked Dawn • 1955

"God has blessed you with children, Señora?"

"Not yet, Señor."

"It will happen. And life will stretch before you like this dusty road."

—desperado Santiago (Arthur Kennedy) and young Maria (Betta St. John)

"It's unseemly to be so frightened at a hanging. Even one's own."

—desperado Santiago (Arthur Kennedy) to young outlaw Manuel (Eugene Iglesias)

Night Passage • 1957

"Funny thing about gold. There's always some jackass who'll find it where the railroad ain't."

—prospector Miss Vittles (Olive Carey) to railroad troubleshooter Grant McLaine (James Stewart)

"Now you're an 'in case' man."

"In case?"

"In case you miss six times with one, you draw the other."

—the Utica Kid (Audie Murphy) and a bit player

"Hello, Joey. What are you doing here?"

"Getting robbed."

—outlaw Whitey Harbin (Dan Duryea) and young Joey Adams (Brandon De Wilde)

Northwest Mounted Police•1940

"Keep your eyes open and your holster closed."

—Sgt. Jim Brett (Preston Foster) to fellow Mountie Ronnie Logan (Robert Preston)

"How can you deliver a baby, set a broken leg, and look lovelier than a Christmas calendar all at once?"

—Mountie Jim Brett (Preston Foster) to nurse April Logan (Madeleine Carroll)

"Jim, I've been transferred to Nova Scotia."

"Nova Scotia? That's the place where the codfish grow, isn't it?"

—nurse April Logan (Madeleine Carroll) and Mountie Jim Brett (Preston Foster)

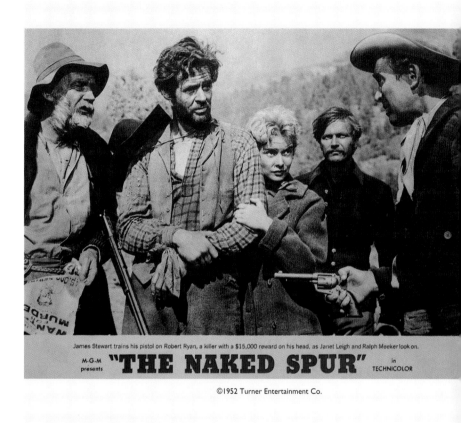

James Stewart trains his pistol on Robert Ryan, a killer with a $15,000 reward on his head, as Janet Leigh and Ralph Meeker look on.

M-G-M presents "THE NAKED SPUR" in TECHNICOLOR

©1952 Turner Entertainment Co.

The Naked Spur•1953

"What's that?"

"You'd better eat it before we tell you."

—bounty hunter Howard Kemp (James Stewart) to prospector Jesse Tate (Millard Mitchell)

"Is dancing hard to learn?"

"No, not the way I do it."

—killer's mistress Lina Patch (Janet Leigh) and bounty hunter Howard Kemp (James Stewart)

"Do you love me?"

"I might, but I don't want to."

—nurse April Logan (Madeleine Carroll) to Mountie Jim Brett (Preston Foster)

"What did you expect Canadian women to look like?"

"Oh, kind of like the scenery. Good to look at but kind of frostbitten."

—nurse April Logan (Madeleine Carroll) to Texas Ranger Dusty Rivers (Gary Cooper)

Northwest Stampede • 1948

"Did you notice the way that dame shot that gun, with her eyes wide open?"

"So what?"

"So what? You know doggone well that half the guys in this country are alive simply because most gals shoot with their eyes shut."

—Clem (bit player) and rodeo champ Dan Bennett (James Craig)

"This old coot's called Mileaway because whenever there's any work to be done, he's always a mile away."

—rodeo champ Dan Bennett (James Craig) to Clem (bit player)

"If I had a gal like you, I'd go for her like a sick cat for a hot stove."

—Mileaway Jones (Chill Wills) to Chris Johnson (Joan Leslie)

Oklahoma! • 1955

"I advise you to get that money off of him before he loses it all. Put it in your stocking or inside your corset where he can't get at it. Or can he?"

—Pa Carnes (James Whitmore) to his daughter Ado Annie (Gloria Grahame)

"Well, Mr. Hakim, I hear you got yourself engaged to Ado Annie. I don't know what to call you. You ain't pretty enough for a skunk, ain't skinny enough for a snake, too low to be a mouse. I reckon you're a rat!"

—Will Parker (Gene Nelson) to Ali Hakim (Eddie Albert)

"Seems like there's times when men ain't got no need for women."

"Well, there's times when women ain't got no need for men."

"Yeah, but who wants to be dead?"

—Ado Annie Carnes (Gloria Grahame) and a stranger (bit player)

"NORTHWEST STAMPEDE"

JOAN LESLIE · JAMES CRAIG · JACK OAKIE
in "NORTHWEST STAMPEDE"

Executive Producer David Hersh · Produced and Directed by Albert S. Rogell
An EAGLE LION FILMS Production

One-Eyed Jacks•1961

"I'm so sorry you're going because I
would like to know you better."
"If you knew me better, you might
wish you hadn't."

—Louisa (Pina Pellicer) and Kid Rio (Marlon Brando)

"You ain't getting no older than
tomorrow."

—deputy marshal Lon (Slim Pickens) to bank robber
Kid Rio (Marlon Brando)

"I never saw a bank two men couldn't
take."

—Kid Rio (Marlon Brando)

Only the Valiant•1951

"I've learned two things in my life. One
of 'em is that you can't even up a
fingernail by biting on it. The other
is that you can't drink a quart of
whiskey every day of your life and
stop it just like that."
"Every day of your life?"
"Well, not quite. Just since I was three
years old."
"Maybe you'd better go back to water."
"Water? That's for fishes."

—Corp. Tim Gilchrist (Ward Bond) and trumpeter Saxton
(Terry Kilburn)

"Captain, this is mighty thirsty work."
"Most work is."

—Corp. Tim Gilchrist (Ward Bond) and Capt. Dick Lance
(Gregory Peck)

The Ox-Bow Incident•1943

"What'll you have, whiskey?"
"What've you got?"
"Whiskey."

—bartender (bit player) and cowpoke Art Croft (Harry
Morgan)

"Whenever he gets low in spirits or
confused in his mind, he doesn't feel
right until he's had a fight."

—cowpoke Art Croft (Harry Morgan) about his sidekick
Gil (Henry Fonda)

The Painted Desert•1931

"I've got something to say to you. I've
got no use for you, and I've been
raised to hate everything that carries
your brand."

—Miss Mary Ellen (Helen Twelvetrees) to Bill Hollbrook
(William Boyd)

Paint Your Wagon • 1969

"You should read the Bible, Mr. Rumson."

"I have read the Bible, Mrs. Fenty."

"Didn't that discourage you about drinking?"

"No, but it sure killed my appetite for reading."

—Mrs. Fenty (Paula Trueman) and drunkard Ben Rumson (Lee Marvin)

"There's two kinds of people—them goin' somewhere and them goin' nowhere."

—drunkard Ben Rumson (Lee Marvin)

The Plainsman • 1937

"Mr. President, I have read an editorial in the *Terra Haute Express*, written by Mr. John B. Searle, in which he says, 'Go West, young man!'"

—Schuyler Colefax (John Hyams) to President Abraham Lincoln (Frank McGlynn Sr.)

"I'm just leaving town."

"You're not leaving town until dead men can walk."

—villain John Latimer (Charles Bickford) and Wild Bill Hickok (Gary Cooper)

"A woman who has a fellow in every stage station and a beau in every cavalry troop west of the Missouri, that woman doesn't need any letters from me!"

"Aw, Bill, those fellers didn't mean nothing to me."

"Well, they did to me."

—Wild Bill Hickok (Gary Cooper) and Calamity Jane (Jean Arthur)

"Take your hands off your guns—or there'll be more dead men here than this town can afford to bury."

—Wild Bill Hickok (Gary Cooper) to a gang of outlaws

"There's no Sunday west of Junction City, no law west of Hay City, and no God west of Carson City."

—Wild Bill Hickok (Gary Cooper) to Louisa Cody (Helen Burgess)

Right: This scene is from the later 1938 remake of *The Painted Desert*, in which the female lead was played by Laraine Johnson and the male lead by George O'Brien. *Following pages:* Film noir collides with the western in director Raoul Walsh's excellent "noir western" *Pursued.* Jeb Rand (Robert Mitchum) must unravel the mystery behind his violent nightmares about his childhood. Here, it's almost too late as the vengeful pursuers catch up with him and his wife, Thorley (Teresa Wright).

76

GEORGE O'BRIEN

IN

R K O RADIO PICTURES

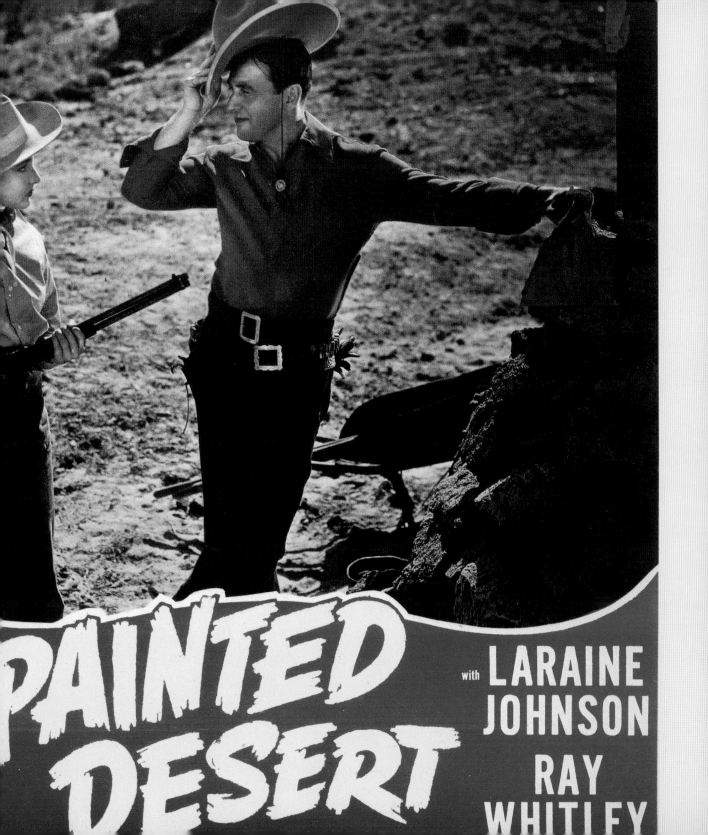

PAINTED DESERT

with **LARAINE JOHNSON**

RAY WHITLEY

The Professionals·1966

"Go to hell."

"Yes, Ma'am. I'm on my way."

—Maria Grant (Claudia Cardinale) and gun-for-hire Bill
Dolworth (Burt Lancaster)

"You bastard!"

"Yes sir. In my case an accident of birth.
 But you, you're a self-made man."

—J. W. Grant (Ralph Bellamy) to hired gun Henry
"Rico" Fardan (Lee Marvin)

Pursued·1947

"A person's got to find his own
answers. We're alone, each of us.
And each in a different way."

—Ma Callum (Judith Anderson) to Jeb Rand (Robert Mitchum)

"Being a lawyer hasn't done your
shooting any good, Grant."

—Ma Callum (Judith Anderson) to hated kinsman Grant
Callum (Dean Jagger)

"This ranch isn't big enough to hold
the two of us."

—Jeb Rand (Robert Mitchum) to Adam Callum (John Rodney)

"See that rise? They'll be comin' over
that. They'll come killing."

—Jeb Rand (Robert Mitchum) to his wife Thorley
(Teresa Wright)

78

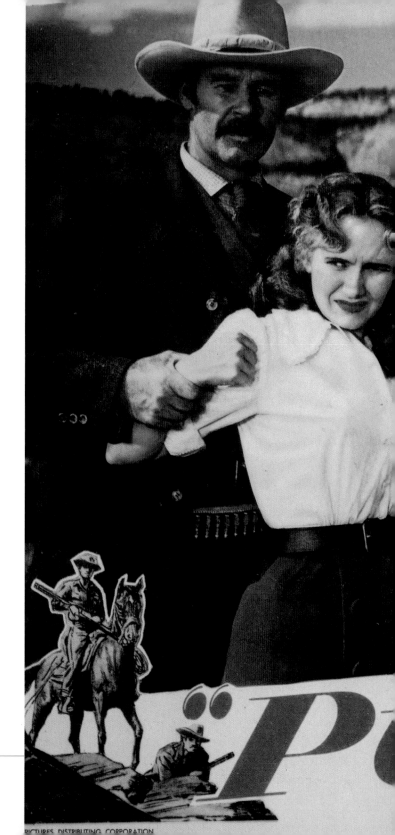

RSUED"

Produced by United States Pictures for Warner

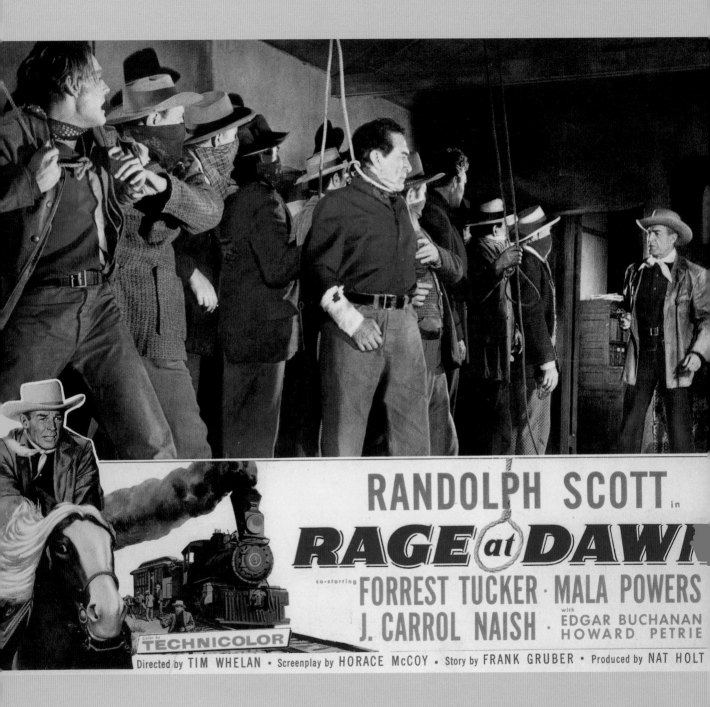

RANDOLPH SCOTT in

RAGE at DAWN

co-starring FORREST TUCKER · MALA POWERS

with J. CARROL NAISH · EDGAR BUCHANAN HOWARD PETRIE

Color by TECHNICOLOR

Directed by TIM WHELAN · Screenplay by HORACE McCOY · Story by FRANK GRUBER · Produced by NAT HOLT

Rachel and the Stranger·1948

"We're proper farmers, Davey, not woodsy folk. A man goes bad if he can't have bread with his meals and a stitched garment on his back."

—homesteader David Harvey (William Holden) to his son Davey (Gary Gray)

Rage at Dawn·1955

"Those kind would never be elected if women had the vote."

—townswoman (bit player)

"You aiming to get yourself killed?"
"On the contrary, I was just planning my future."

—outlaw Frank Reno (Forrest Tucker) and range detective James Barlow (Randolph Scott)

Ramrod·1947

"From now on, I'm going to make a life of my own. And being a woman, I won't have to use guns."

—Connie Dickason (Veronica Lake) to her father, cattle baron Ben (Charlie Ruggles)

Rancho Notorious·1952

"How is he, Doc?"
"Well, he suffered lacerations, contusions, and concussion. His jugular vein was severed in three places. I counted four broken ribs and a compound fracture of the skull. To put it briefly, he's real dead."

—Sheriff Bullock (William Haade) and doctor (bit player)

"You're wanted, aren't you?"
"Let's say I'm in public demand."

—saloon hostess Altar Keene (Marlene Dietrich) and gambler Frenchie Fairmont (Mel Ferrer)

Rawhide·1951

"When he cracks the whip, men and mules just lay back their ears and take orders."

—stagecoach station manager Sam (Edgar Buchanan) to new assistant Tom Owens (Tyrone Power)

"Little more coffee, Mr. Slade?"
"Coffee? This stuff tastes like burnt corn boiled in branch water."

—stagecoach station manager Sam (Edgar Buchanan) and stagecoach passenger (bit player)

Background: Former saloon hostess Altar Keene (Marlene Dietrich) and gambler Frenchie Fairmont (Mel Ferrer) are lovers who run a notorious outlaw hideout called Chuckaluck in director Fritz Lang's expressionistic *Rancho Notorious.* *Opposite:* Range detective James Barlow (Randolph Scott) succeeds in capturing the notorious Reno Brothers, but a mob lynches the gang without giving them a fair trial in *Rage at Dawn.*

"What are you afraid of, coyotes?"
"Yeah, the kind with boots on."
—stagecoach station assistant manager Tom Owens (Tyrone Power) and passenger Vinnie Holt (Susan Hayward)

"She's doin' what you oughtta do once
in a while. Takin' a bath."
"Keep dry outside and wet inside.
That's what a man does in this
country."
—stagecoach station assistant manager Tom Owens (Tyrone Power) and his boss Sam (Edgar Buchanan)

Red River • 1948
"I don't like quitters. Especially when they're not good enough to finish what they started!"
—cattleman Tom Dunsom (John Wayne)

"You know, there are only two things more beautiful than a good gun—a Swiss watch or a woman from anywhere."
—Jerry Valance (John Ireland)

Ride the High Country • 1962
"A good marriage is like a rare animal. Hard to find, almost impossible to keep."
—Judge Tolliver (Edgar Buchanan) to Elsa Knudsen (Mariette Hartley) and prospector Billy Hammond (James Drury)

"You know what's on the back of a
poor man when he dies? The
clothes of pride. And they are not a
bit warmer to him dead than they
were when he was alive. Is that all
you want, Steve?"
"All I want is to enter my house
justified."
—Gil Westrum (Randolph Scott) and Steve Judd (Joel McCrea)

Rio Bravo • 1959
"If I'm going to get shot at, I might as well get paid for it. How do I get a badge?"
—Colorado Kid (Ricky Nelson) to Sheriff John T. Chance (John Wayne)

Rio Conchos • 1964

"How a man gets his money does not matter. It's how he spends it, amigo."
—Mexican desperado Juan Luis Rodriguez (Tony Franciosa) to adventurer Lassiter (Richard Boone)

"We can't just leave her there."
"You can't. I can."
—Capt. Haven (Stuart Whitman) and adventurer Lassiter (Richard Boone)

"You are stupid enough to become a general."
—adventurer Lassiter (Richard Boone) to Capt. Haven (Stuart Whitman)

"On my father's honor. Whoever he was."
—Mexican desperado Juan Luis Rodriguez (Tony Franciosa) to adventurer Lassiter (Richard Boone)

Rio Grande • 1950

"Are you arresting that nice young man for manslaughter?"
"Not me, Ma'am. A United States marshal."
—Mrs. Kathleen York (Maureen O'Hara) and a soldier (bit player)

JOHN STEINBECK'S great American story!

MYRNA **LOY** · ROBERT **MITCHUM** in *The RED PONY*
Color by TECHNICOLOR
A REPUBLIC PRODUCTION

The Red Pony • 1949

"Can't know life until you see death. It's all part of one thing."
—Grandpa (Louis Calhern) to his family

"How was the water?"

"Freezing. But I'm becoming hardened. I guess it's from seeing life in the raw and running around with strong silent types like you guys."

—young Mark Calder (Tommy Rettig) and dance hall girl Kay Weston (Marilyn Monroe)

Rough Night in Jericho•1967

"Been a widow very long?"

"Not long enough for it to bother me. So don't let it bother you."

—Mr. Dolan (George Peppard) and Molly Lang (Jean Simmons)

The Rounders•1965

"Whatever suits you just tickles me plumb to death."

—cowboy Howdy Lewis (Henry Fonda)

"Do you know what a bronc rider is?"

"What?"

"He's a cowboy with his brains kicked out."

—cowboy Ben Jones (Glenn Ford) and cowboy Howdy Lewis (Henry Fonda)

Above: Gloria Grahame, playing a dance hall girl, made a rare appearance in a western in *Roughshod* (1949). Her co-star John Ireland was in over 25 westerns, including such classics as *Red River* and *Gunfight at the O.K. Corral.* *Opposite:* Hard-luck cowboy Ben Jones (Glenn Ford) tries unsuccessfully to bust an omery bronco in *The Rounders.* Director Burt Kennedy wrote the wry and eloquent script with Max Evans, on whose novel the film was based.

River of No Return•1954

"Gold. It made a thief out of Weston, a pig out of Colby, and a fool out of you."

—river guide Matt Calder (Robert Mitchum) to dance hall girl Kay Weston (Marilyn Monroe)

"One thing about you, though. You get somebody into trouble, and you get right in it with them."

—river guide Matt Calder (Robert Mitchum) to dance hall girl Kay Weston (Marilyn Monroe)

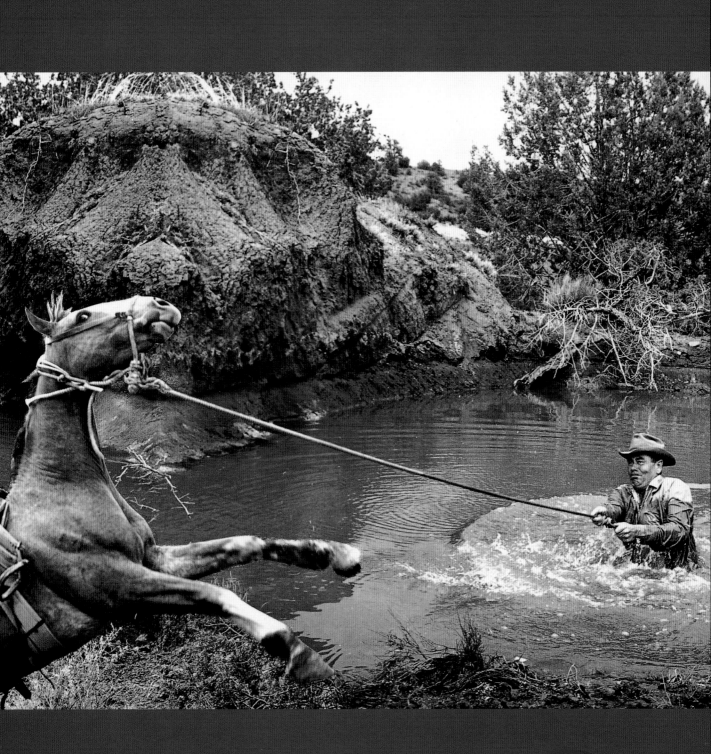

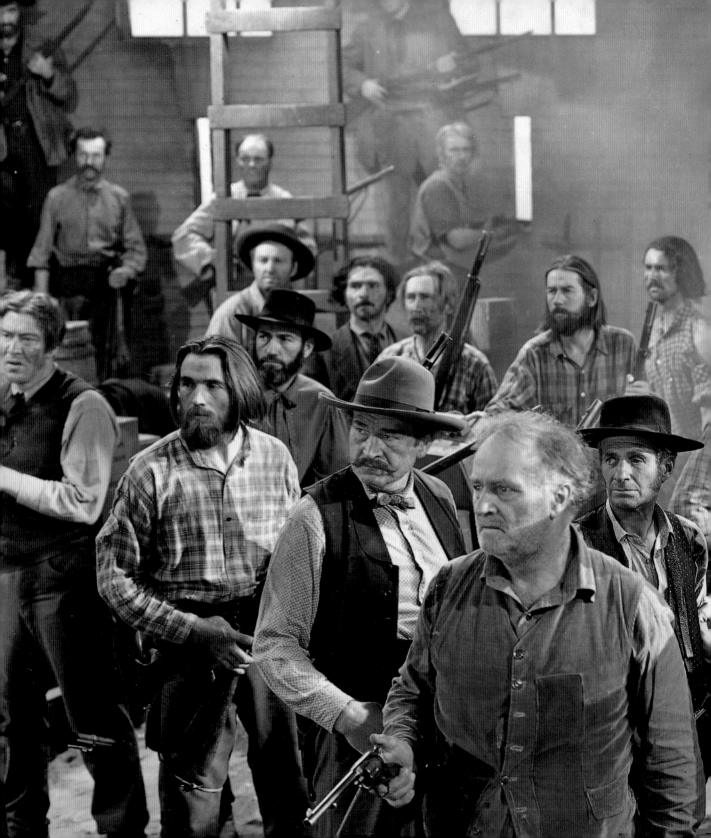

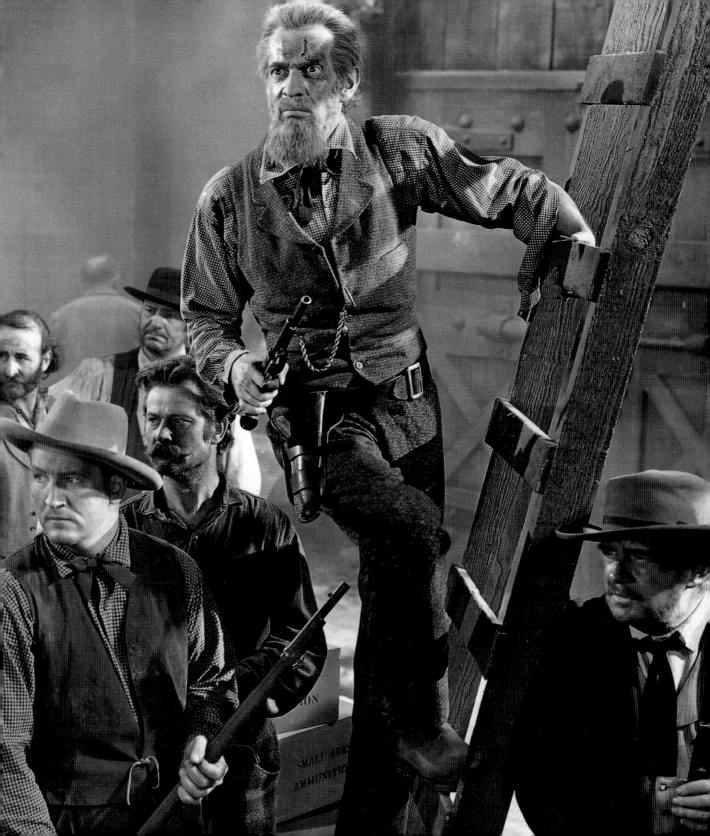

Ruggles of Red Gap • 1935

"You know Effie. I tell you, when she gets riled up, she, why she'd fight a rattlesnake and give it the first two bites."

—westerner Egbert Floud (Charlie Ruggles) to aristocrat George Van Bassingwell (Roland Young)

"That woman could bite through nails."
"She chews them instead of gum."

—Jeff Tuttle (James Burke) and Egbert Floud (Charlie Ruggles)

"Do you believe in love at first sight?"
"No, do you?"
"No, that's why I'd like to stay a little while, if I may."

—aristocrat George Van Bassingwell (Roland Young) and Nell Kenner (Leila Hyams)

Santa Fe Trail • 1940

"The road to Santa Fe was on iron rails to Kansas, and pure nerve from there on."

—title card

"They outnumber us three to one!"
"Well, if it makes you nervous, don't count them."

—young soldiers George Armstrong Custer (Ronald Reagan) and Jeb Stuart (Errol Flynn)

"Well, see, we had to buy these knickknacks, for we've sort of got a girl in Santa Fe."
"What do you mean we? *I'm* engaged to her."
"Well, who ain't?"

—Windy Brody (Guinn "Big Boy" Williams) and Tex Bell (Alan Hale)

"Kansas is all right for men and dogs. But it's pretty hard on women and horses."

—bit player

The Searchers • 1956

"I say we do it my way—and that's an order."
"Yes, sir. But if you're wrong, don't ever give me another."

—Reverend S. Johnson Clayton (Ward Bond) and Ethan Edwards (John Wayne)

"You know, Laurie, I was just thinking that maybe it's time you and me started going steady, huh?"
"Well, Martin Pauley. You and me's been going steady since we was three years old."
"We have?"
" 'Bout time you found out about it."

—Martin Pauley (Jeffrey Hunter) and Laurie (Vera Miles)

Shane • 1953

"A gun is as good or bad as the man using it."

—drifter Shane (Alan Ladd) to young Joey Starrett (Brandon De Wilde)

"Some like to have two guns, but one's all you need if you know how to use it."

—drifter Shane (Alan Ladd) to young Joey Starrett (Brandon De Wilde)

She Wore A Yellow Ribbon • 1949

"The army will never be the same when we retire, sir."
"The army is always the same. The sun and the moon change, but the army knows no seasons."

—Sgt. Quincannon (Victor McLaglen) and Capt. Nathan Brittles (John Wayne)

"It's an abuse of the taxpayers' money. I told them, sir!"
"The only tax you ever paid was a whiskey tax!"

—Sgt. Quincannon (Victor McLaglen) and Capt. Nathan Brittles (John Wayne)

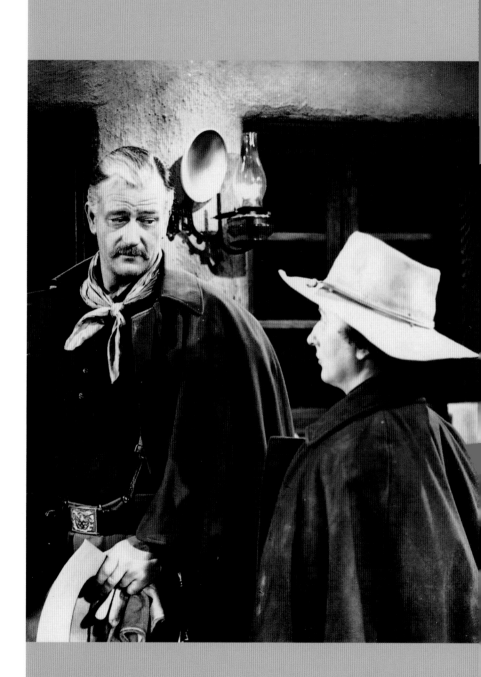

The Showdown

1950

"You're not going to live long enough to wear out those britches if you don't quit using gunpowder for brains."
—Capt. MacKeller (Walter Brennan) to Rod Main (Henry Morgan)

"I don't want trouble with anybody—unless I start it."
—ex-lawman Shadrach Jones (William "Wild Bill" Elliott) to Capt. MacKeller (Walter Brennan)

"Filling a man's stomach is like greasin' a dry wheel— takes the growl out of him."
—Capt. MacKeller (Walter Brennan) to ex-lawman Shadrach Jones (William "Wild Bill" Elliott)

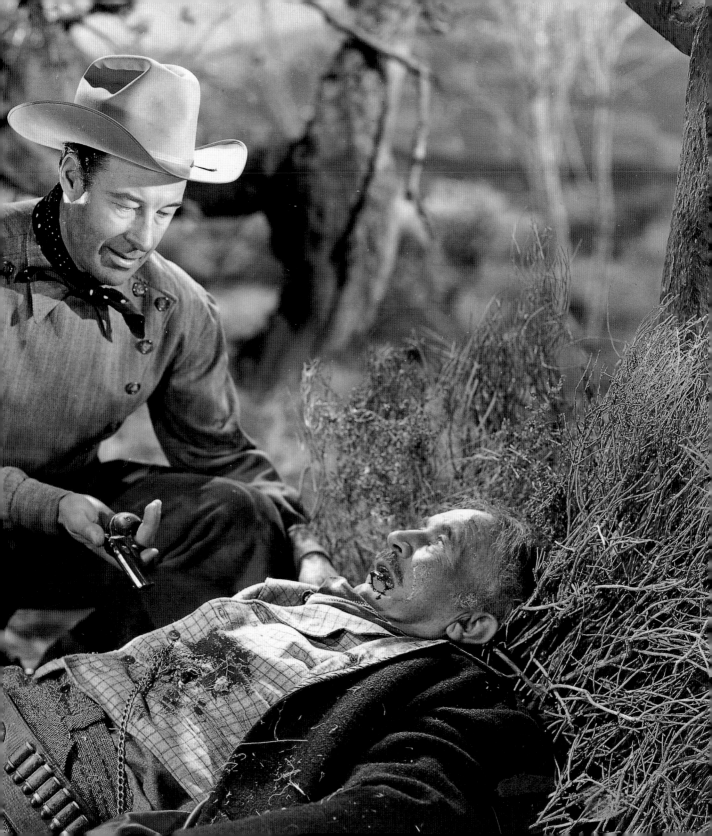

Springfield Rifle

1952

"Kind of used to giving orders, aren't you?"

"What's worse, I'm used to being obeyed."

—gun runner Austin McCool (David Brian) and Maj. Lex Kearny (Gary Cooper)

"If you were a good mother, you'd be at home now!"

—Maj. Lex Kearny (Gary Cooper) to his wife Eden (Phyllis Thaxter)

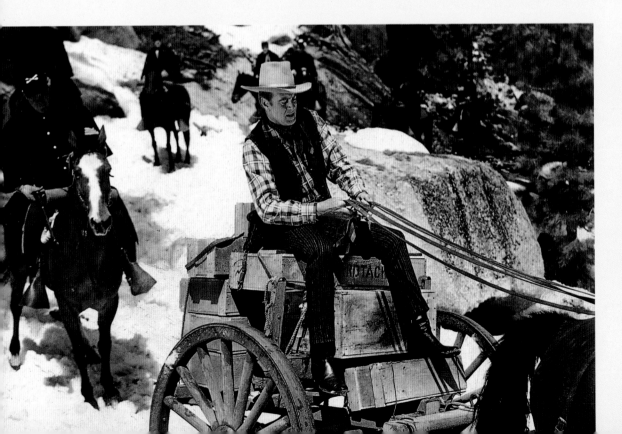

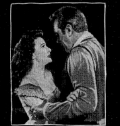

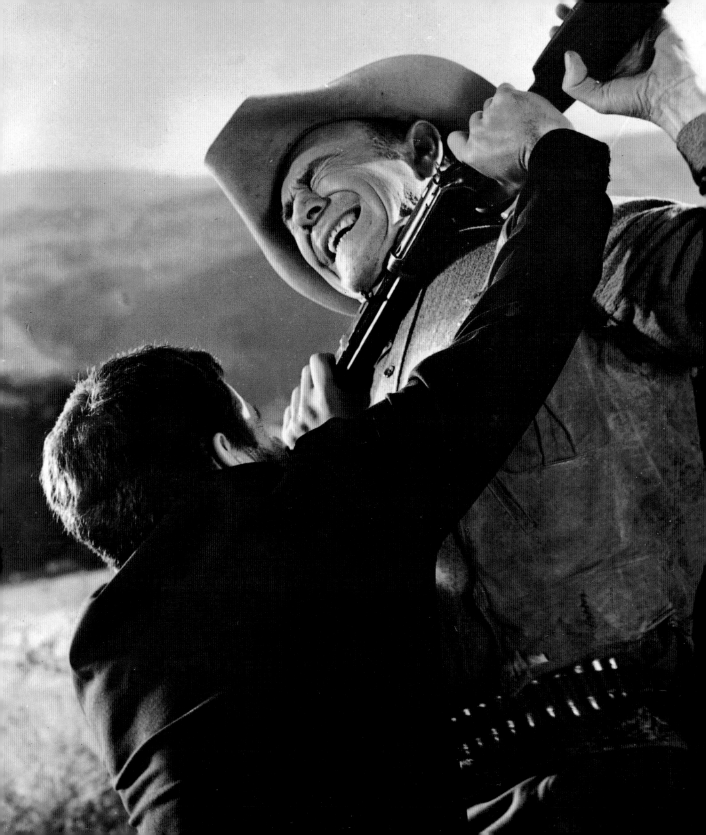

The Southerner • 1945

"The earth's sort of like men. Needs a rest every once in a while."

—farmer Sam Tucker (Zachary Scott) to his wife Nona (Betty Field)

"You'll all look down on my cold, dead face in that country pine box. You'll be sorry then, maybe."
"You keep on promising, Granny. You don't never deliver the goods."

—Granny Tucker (Beulah Bondi) and Nona Tucker (Betty Field)

Stagecoach • 1939

"There's some things a man just can't run away from."

—Ringo Kid (John Wayne)

"Well, I guess you can't break out of prison and into society in one week."

—Ringo Kid (John Wayne)

Stars in My Crown • 1950

"May as well smoke here. Can't smoke in the hereafter."

—Dr. Daniel Kalbert Harry Sr. (Lewis Stone) to parson Josiah Doziah Gray (Joel McCrea)

Previous pages: Maj. Lex Kearny (Gary Cooper) plays an army officer who goes undercover in order to catch a gang of thieves who steal Union horses and arms to sell to the Confederacy in director Andre De Toth's *Springfield Rifle.*
Left: Rancher Don McGowan (Mike McGowan) struggles with a would-be thief (bit player) who's trying to steal his daughter's prize horse in *Snowfire* (1958).

"You look spryer than a jaybird to
 me."
"If the truth be known, I've walked out
 of my front door for the last time.
 Next time I make the trip, I'll be
 riding in style and you'll be helping
 carry me."
—parson Josiah Doziah Gray (Joel McCrea) and Dr. Daniel
Kalbert Harry Sr. (Lewis Stone)

"Every man born has something the
matter with him, and if you're looking
for the perfect man, you'll never find
him."
—Harriet Gray (Ellen Drew) to her friend Faith Samuels
(Amanda Blake)

Station West • 1948
"They don't shoot so straight."
"They don't need to when they shoot
 so often."
—undercover army officer Haven (Dick Powell) and
stagecoach driver (bit player)

"Can't you put that gun away?"
"I can, but it helps quiet my nerves."
—lawyer Mark Bristow (Raymond Burr) and undercover
army officer Haven (Dick Powell)

"That lieutenant's a nice boy."
"I don't doubt it. But his mouth's too
 big—like your ears."
—undercover army officer Haven (Dick Powell) and
bartender (John Doucette)

"Are you always this sweet to the men
 who fight over you?"
"Only the winners."
—undercover army officer Haven (Dick Powell) and saloon
owner Charlie (Jane Greer)

"I don't intend to start at the bottom.
Been there. It's too crowded."
—undercover army officer Haven (Dick Powell) to saloon
owner Charlie (Jane Greer)

**The Stranger Wore a
Gun • 1953**
"Where are you going?"
"I need a drink. Maybe five or six."
—Josie Sullivan (Claire Trevor) and Lt. Jeff Travers
(Randolph Scott)

"Feel how still the air is. Like just
before a cyclone, or a storm, or a
death."
—Josie Sullivan (Claire Trevor) to outlaw Jules Mourret
(George Macready)

96

"Breathe deep, Mister. While you can."

—badman Bull Slager (Ernest Borgnine) to Lt. Jeff Travers
(Randolph Scott)

"I must apologize for my men, but we both know that civilization ends with the Mason-Dixon line."

—badman Jules Mourret (George Macready) to Lt. Jeff Travers (Randolph Scott)

"I didn't get your name."

"That's right."

"Gabby sort of a feller."

—Jake Hooper (bit player) and Lt. Jeff Travers
(Randolph Scott)

Streets of Laredo•1949

"No matter where, there's nothing sweeter than the scent of lavender."

"Yeah, until it turns sour."

"Whoever it was and whatever she did, it wasn't good for you, amigo."

—outlaws Lorn Reming (MacDonald Carey) and Jim Dawkins (William Holden)

"He wasn't much of a hand at nothing but a jug, but he was decent enough to me. I sure hope there's plenty enough of filled-up jugs where he's gone."

—Ronnie Carter (Mona Freeman) to outlaw Jim Dawkins (William Holden)

"Them Rangers are sure making it tough to hustle a dishonest dollar these days."

—Wahoo Jones (William Bendix) to fellow outlaw Jim Dawkins (William Holden)

Support Your Local Sheriff!•1969

"You want me to tell Joe Danby that he's under arrest for murder? What're you gonna do after he kills me?"

"Then I'll arrest him for both murders."

—Jake (Jack Elam) and Sheriff Jason McCullough (James Garner)

Tall in the Saddle•1944

"Supper, Dave?"

"I'm drinking mine."

—bartender Cap (Cy Kendall) and stagecoach driver Dave (Gabby Hayes)

"I saw you! I saw you strike that poor man!"

"Yes, Ma'am. Just as hard as I could."

—Miss Martin (Elisabeth Risdon) and cowhand Rocklin (John Wayne)

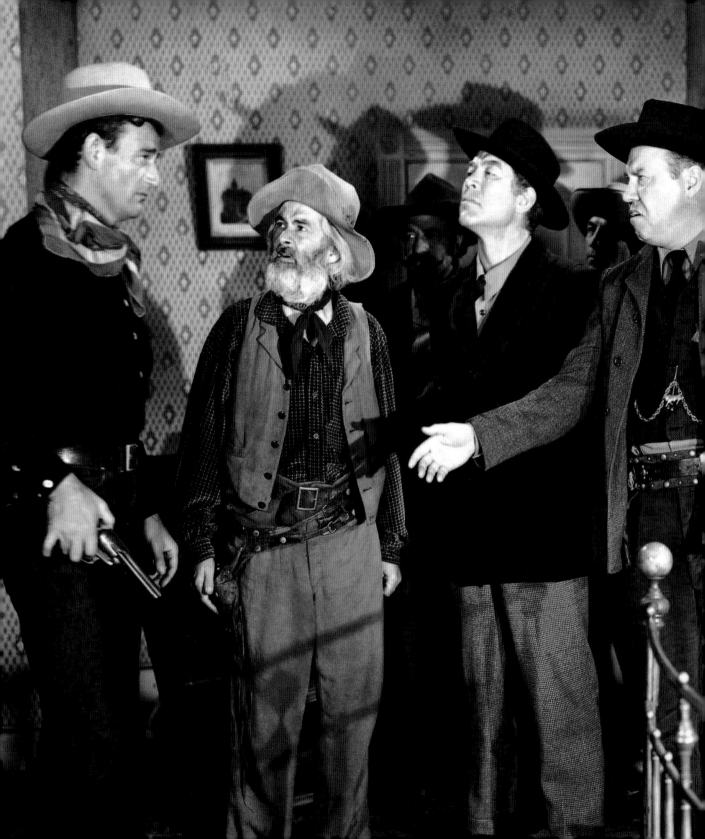

"I like grumpy old cusses. Hope to live long enough to be one."

—cowhand Rocklin (John Wayne)

"He ain't dead, is he?"

"Not permanently."

—bit player and stagecoach driver Dave (Gabby Hayes)

"You might as well know right now that no woman is going to get me hog-tied and branded."

—cowhand Rocklin (John Wayne) to rancher Arly Harolday (Ella Raines)

3:10 to Yuma • 1957

"Safe. Who knows what's safe? I know a man dropped dead from looking at his wife. My own grandmother fought the Indians for sixty years, then choked to death on lemon pie."

—marshal (Ford Rainey)

Thunder over the Plains • 1953

"You'll stay in custody till we get back."

"What for?"

"In case you're a better liar than you look."

—Capt. David Porter (Randolph Scott) and prisoner (bit player)

Tombstone (aka *Tombstone, the Town Too Tough to Die*) • 1942

"Draw fast and shoot slow, that's my motto. Then you never miss what you're aiming at."

—Wyatt Earp (Richard Dix)

"What brought you here?"

"My horse."

—badman Curly Bill (Edgar Buchanan) and Johnny Duane (Don Castle)

"You aiming to stay on here, Doc?"

"Yeah, the doctors tell me that the fine Arizona air you get in pool halls and saloons might do me some good."

"You stay in Tombstone, I guarantee you won't die in bed."

—Wyatt Earp (Richard Dix) and Doc Holliday (Kent Taylor)

"Pull off my boots, will ya?"

"Sure, kid, sure."

"I promised my mother I wouldn't die with my boots on."

—dying Tadpole (Clem Bevans) and Ike Clanton (Victor Jory)

Opposite: A stranger in town, Rocklin (John Wayne) confronts an angry mob with the help of his sidekick, Dave (George "Gabby" Hayes), in *Tall in the Saddle.*

Tribute to a Bad Man•1956

"A horse is man's slave, but treat 'em like a slave and you're not a man. Remember that."

—rancher Jeremy Rodack (James Cagney) to Easterner Steve Millar (Don Dubbins)

"You act like a man with a lot of ideas, all of them second-rate and not one of them honorable."

—rancher Jeremy Rodack (James Cagney) to cowboy McNulty (Stephen McNally)

"That's what a wrangler is: a nobody on a horse—with bad teeth, broken bones, a double hernia, and lice."

—Jocasta Constantine (Irene Papas) to Easterner Steve Millar (Don Dubbins)

"Don't worry. A fellow doesn't die of a broken heart from his first love. Only from his last."

—rancher Jeremy Rodack (James Cagney) to his mistress Jocasta Constantine (Irene Papas) about young Easterner Steve Millar (Don Dubbins)

100

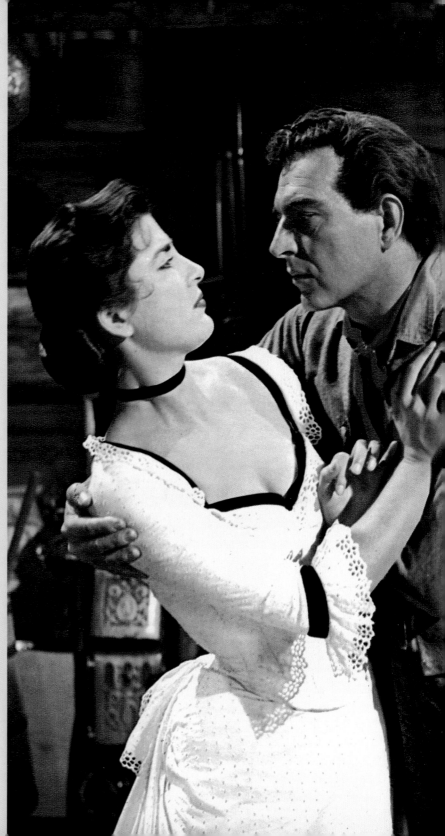

Treasure of the Sierra Madre • 1947

"I caught this guy stealing our water. Next time you try that, I'll let it out of you through little round holes."

—prospector Fred C. Dobbs (Humphrey Bogart) to Herman Brix (Bruce Bennett)

"Gold don't carry any curse with it. It all depends on whether or not the guy who finds it is a right guy. The way I see it, gold can be as much of a blessing as a curse."

—prospector Fred C. Dobbs (Humphrey Bogart)

"Fred C. Dobbs don't say nothin' he don't mean."

—prospector Fred C. Dobbs (Humphrey Bogart)

True Grit • 1969

"Mr. La Boeuf, I have no regard for you. But I'm sure you have enough for yourself to go around."

—14-year-old Mattie Ross (Kim Darby) to Texas Ranger La Boeuf (Glen Campbell)

"That man gave his life for him, and he didn't even look back."
"Looking back is a bad habit."

—14-year-old Mattie Ross (Kim Darby) and Marshal Rooster Cogburn (John Wayne)

"Who are you?"
"Nobody yet. But I expect to go high."

—14-year-old Mattie Ross (Kim Darby) and Texas Ranger La Boeuf (Glen Campbell)

The Unforgiven • 1960

"Fine looking bunch of riders you've got there."
"I hand-picked them off the barroom floor. They're sober now."

—Cash Zachary (Audie Murphy) and his brother Ben (Burt Lancaster)

"Nothing could kill me, except lightning out of the sky. And then it would have to hit twice."

—Ben Zachary (Burt Lancaster) to his mother Mathilda (Lillian Gish)

"When they get close enough so you want to scream, don't scream. Shoot."

—Ben Zachary (Burt Lancaster) to his sister Rachel (Audrey Hepburn)

"That's Wichita whiskey, Momma. It's aged four minutes, and that ain't long enough to cure whatever's in it."

—Cash Zachary (Audie Murphy) to his mother Mathilda (Lillian Gish)

Opposite: Ranch hand McNulty (Stephen McNally) tries to force himself on the boss's wife, Jocasta (Irene Papas in her Hollywood debut), in *Tribute to a Bad Man,* which also stars James Cagney in one of his few westerns.

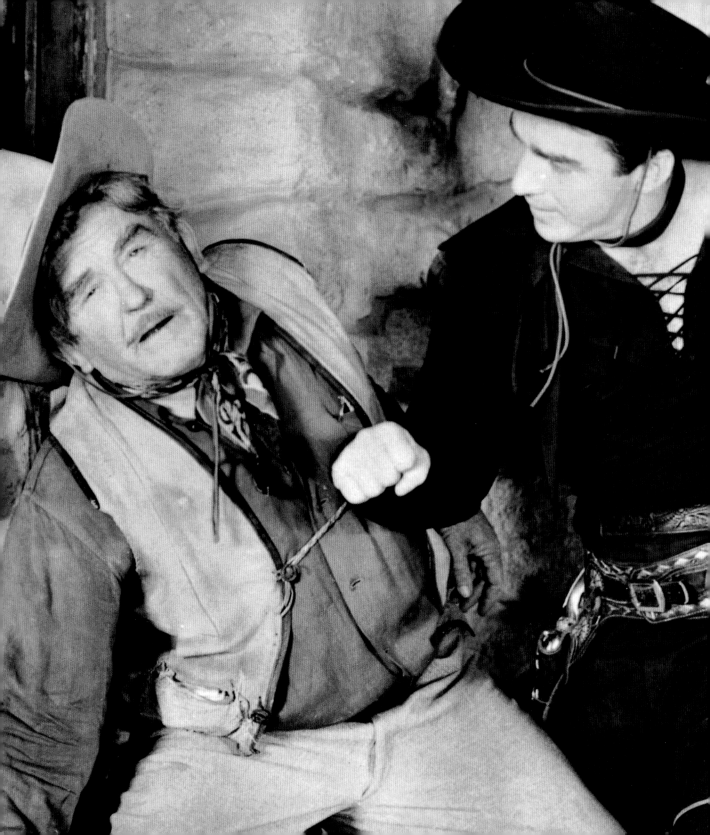

Union Pacific•1939

"No one's ever put any sense into a man's brain through a bullet hole in his head."

—Mollie Monahan (Barbara Stanwyck) to railroad troubleshooter Jeff Butler (Joel McCrea)

"A railway from Omaha to California? One might as well think of flying!"

—United States Senator Smith (Morgan Wallace)

"Darling, will you kindly hold your temper, your tongue, and your two little fists?"
"They ain't little!"

—con man Dick Allen (Robert Preston) and Mollie Monahan (Barbara Stanwyck)

Vera Cruz•1954

"Soft spot, eh?"
"Only for horses."

—soldiers of fortune Joe Aaron (Burt Lancaster) and Ben Trayne (Gary Cooper)

"I don't trust him. He likes people, and you can never count on a man like that."

—adventurer Joe Aaron (Burt Lancaster) about his fellow traveler Ben Trayne (Gary Cooper)

Left: Except for his first film, Lash LaRue (who always played the role of Lash LaRue) was a good guy despite his trademark all-black outfit. Here he dukes it out with his fists instead of his famous bullwhip in *The Vanishing Outpost* (1951).

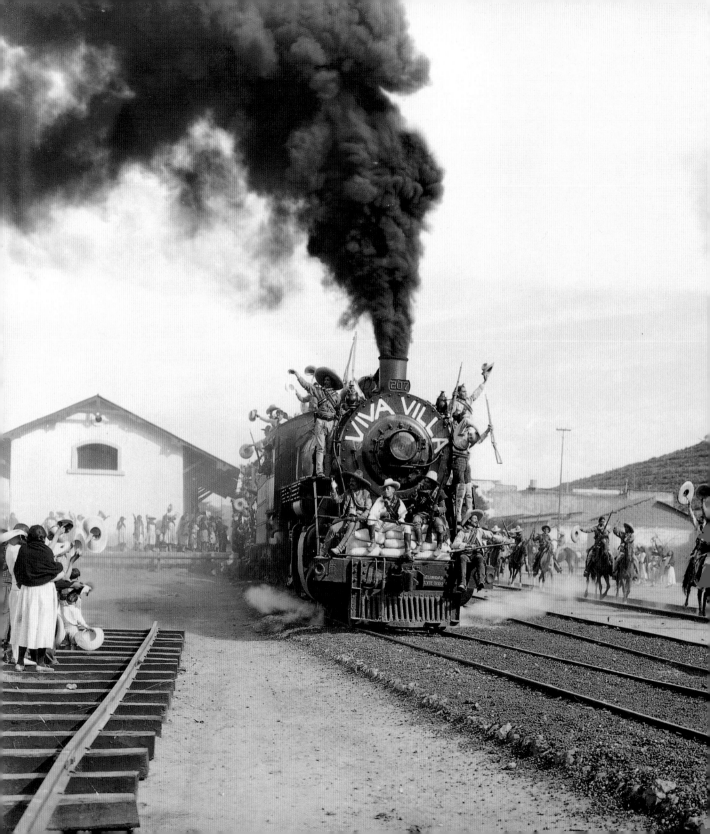

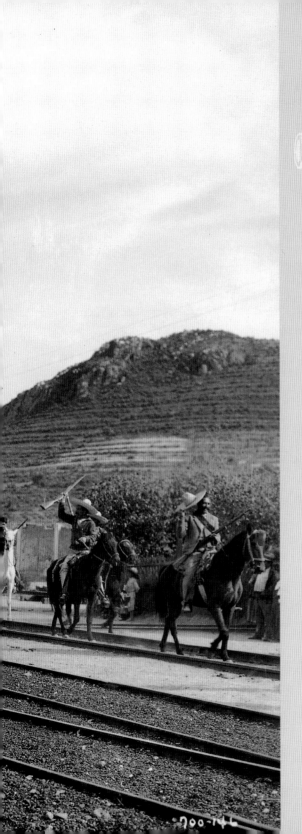

Viva Villa!

1934

"You're better than news—you're history!"

—reporter Johnny Sykes (Stuart Erwin) to rebel leader Pancho Villa
(Wallace Beery)

The Violent Men • 1955

"Temper's something only the very strong or the very rich can afford. My father taught me that very early."

—rancher John Parrish (Glenn Ford) to his foreman Jim McCloud (Warner Anderson)

"Never meet the enemy on his terms."

—rancher John Parrish (Glenn Ford) to his foreman Jim McCloud (Warner Anderson)

"Men always find reasons to avoid living in peace."

—Doc Henry Crowell (Raymond Greenleaf) to rancher John Parrish (Glenn Ford)

The Virginian • 1929

"When I want to know anything from you, I'll tell you, you long-legged son of a—"
"If you want to call me that, smile."

—Trampas (Walter Huston) and "The Virginian" (Gary Cooper)

"Hey, that boy's so smart he'd dry snow and sell it for sugar."

—"Honey" Wiggin (Eugene Pallette)

Wagon Master • 1950

" 'Hell' ain't cussing. It's geography, the name of a place. Like you might say Abilene or Salt Lake City."

—Sandy (Harry Carey Jr.) to Jackson (Chuck Hayward)

"You like him, don't you?"
"I don't want to see him full of bullet holes, if that's what you mean."

—Fleuretty Phyffe (Ruth Clifford) and Denver Smythe (Joanne Dru) about the wagon master, Travis (Ben Johnson)

War Arrow • 1954

"Still a sergeant, eh, Schermerhorn?"
"Yes, sir. I guess soldiers are like water—they find their own level."

—Col. Jackson Meade (John McIntire) and Sgt. Schermerhorn (Charles Drake)

"That Schermerhorn—why that fella could charm the Rocky Mountains into going south for the winter."

—Sgt. Augustus Wilks (Noah Beery Jr.)

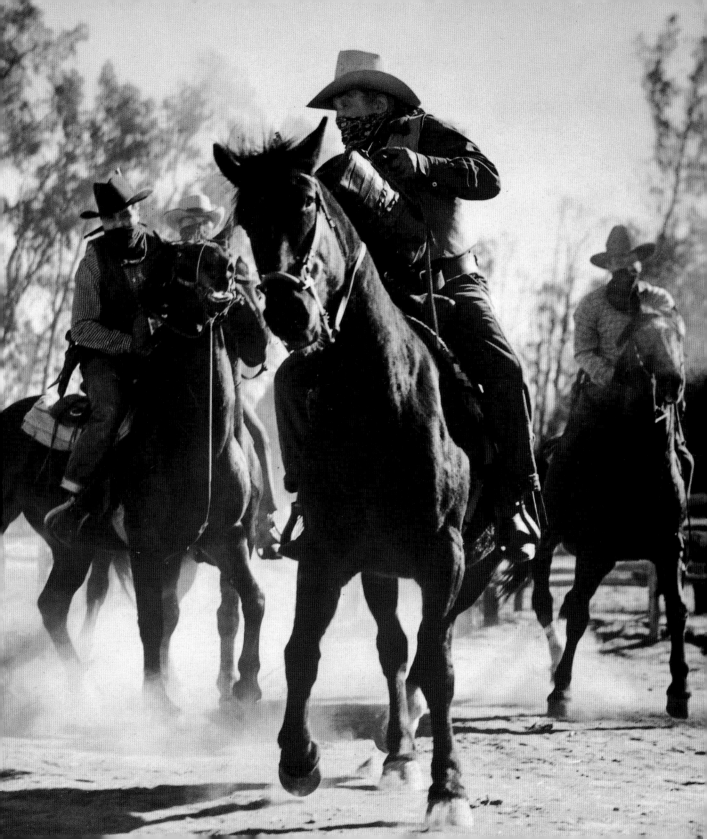

Warlock•1959

"Maybe they can't hold guns, but they sure can hold meetings."

—gambler Tom Morgan (Anthony Quinn) to his pal Marshal Clay Blaisdell (Henry Fonda) about the city fathers

The War Wagon•1967

"Enjoy your drink. It'll be your last."

"Well, that'd be a shame. I kind of
 hoped that my last drink would be a
 big one."

—gunslinger Lomax (Kirk Douglas) and Taw Jackson (John Wayne)

"You'd shoot me in the back?"

"You deserve it. You've caused me a
 lot of embarrassment."

"How's that?"

"You're the only man I ever shot I
 didn't kill."

—Taw Jackson (John Wayne) and gunslinger Lomax (Kirk Douglas)

"Any limit?"

"If there was, you wouldn't play."

—gunslinger Lomax (Kirk Douglas) and saloon girl Lola (Joanna Barnes)

The Westerner•1940

"Don't spill that liquor, son. It eats right through the bar."

—Judge Roy Bean (Walter Brennan)

"This is fine liquor—what do you call it?"

"Rub of the Brush."

—drifter Cole Hardin (Gary Cooper) and Judge Roy Bean (Walter Brennan)

"Don't you trust me, Cole?"

"When I was a kid, I had a pet
 rattlesnake. I was fond of it, but I
 wouldn't turn my back on it."

—Judge Roy Bean (Walter Brennan) and drifter Cole Hardin (Gary Cooper)

Western Union•1941

"Howdy, stranger. Sorry, but I'm going to have to borrow your horse for a spell. I reckon I'd better borrow your gun too."

—badman Vance Shaw (Randolph Scott) to Edward Creighton (Dean Jagger)

"I could do with a bath."

"A bath?"

"Yes. Don't you approve of them?"

"Well, if the weather's hot and you're
 near a river, I haven't got a thing
 against them."

—Easterner Richard Blake (Robert Young) and Homer
Kettle (Chill Wills)

Westward the Women • 1951

"Two things in this world scare me.
And a good woman's both."

—wagontrain master Buck Wyatt (Robert Taylor) to Roy
Whitman (John McIntire)

The Wild Bunch • 1969

"It's gettin' so a feller can't sleep with
both eyes closed for fear of getting his
throat cut."

—outlaw Lyle Gorch (Warren Oates) to the Wild Bunch
gang

"We all dream of being a child again,
even the worst of us. Perhaps the
worst most of all."

—Mexican elder (bit player) to Wild Bunch leader Pike
Bishop (William Holden)

"It's not your word—it's who you give
it to."

—outlaw Dutch Engstrom (Ernest Borgnine)

Winchester '73 • 1950

"That's an awful lot of law for a little
 cowtown."

"This is the kind of little cowtown that
 needs a lot of law."

—drifter Lin McCaddam (James Stewart) and Wyatt Earp
(Will Geer)

"You're about the lowest thing I've
ever seen standing in a pair of boots."

—saloon girl Lola Manners (Shelley Winters) to outlaw
Waco Johnny Dean (Dan Duryea)

"Haven't I seen you somewhere?"

"I've been somewhere."

—Dutch Henry Brown (Stephen McNally) and saloon girl
Lola Manners (Shelley Winters)

Opposite background: Clint McCoy
(Rory Calhoun) is a world-weary
gunslinger who reunites with the
hell-rising son he deserted, Tige
(Preston Pierce), to defend the
town from the notorious Dawson
gang in *Young Fury* (1965).

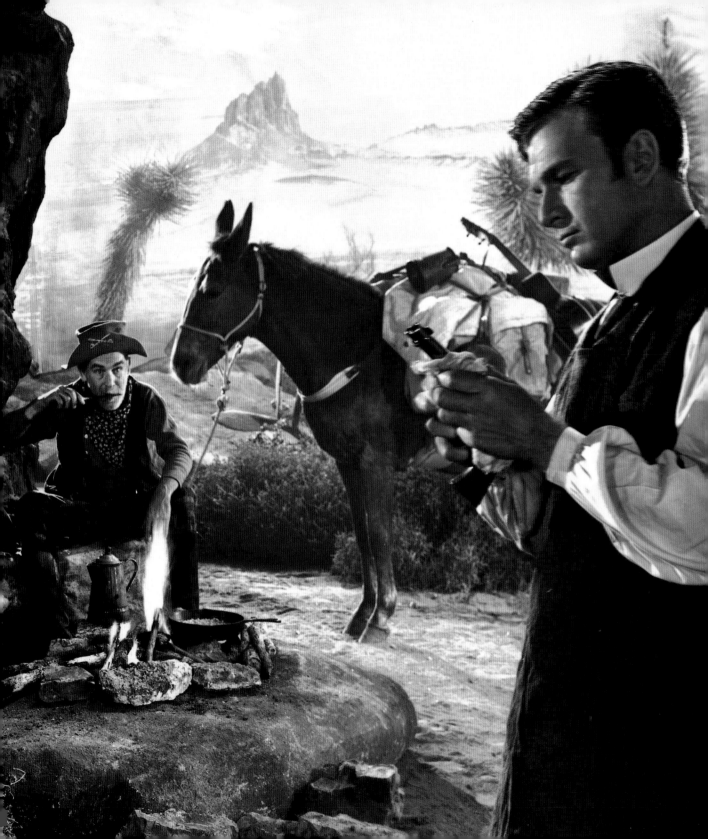

Index of Actors, Directors and Writers

References to captions are in *italic type*.

Opposite: Easterner Daniel Bone (Eddie Albert) cleans his gun while making camp with an old-timer (bit player) on the adventure-filled trail to Arsenic City in the comedy western *The Dude Goes West* (1948).

Index of First Lines

Screenwriters

Across the Wide Missouri: Talbot Jennings, story by Talbot Jennings and Frank Cavett from Bernard DeVoto's book / *The Alamo:* James Edward Grant / *Along Came Jones:* Nunnally Johnson from Alan LeMay's story / *Angel and the Badman:* James Edward Grant / *Apache:* James R. Webb from Paul Wellman's novel *Broncho Apache* / *Apache Uprising:* Max Lamb and Harry Sanford from Harry Sanford and Max Steeber's novel / *Arizona:* Claude Binyon from Clarence Buddington Kelland's story / *Arrow in the Dust:* Don Martin from L. L. Foreman's novel / *Bad Day at Black Rock:* Millard Kaufman, adaptation by Don McGuire from Howard Breslin's story / *The Badlanders:* Richard Collins from W. R. Burnett's novel *The Asphalt Jungle* / *The Ballad of Cable Hogue:* John Crawford and Edmund Penney / *Bar 20 Justice:* Arnold Belgard and Harrison Jacobs from Clarence E. Mulford's story / *The Beautiful Blonde from Bashful Bend:* Preston Sturges from Earl Fenton's story / *Best of the Badmen:* Robert Hardy Andrews and John Twist from Robert Hardy Andrews's story / *The Big Country:* James R. Webb, Sy Bartlett and Robert Wyler, adaptation by Jessamyn West and Robert Wyler from Donald Hamilton's novel / *A Big Hand for the Little Lady:* Sidney Carroll / *The Big Sky:* Dudley Nichols from A. B. Guthrie Jr.'s novel *The Big Sky* / *The Big Trail:* Jack Peabody, Marie Boyle and Florence Postal from Hal G. Evarts's story / *Broken Arrow:* Michael Blankfort from Elliott Arnold's novel *Blood Brother* / *Broken Lance:* Richard Murphy from Philip Yordan's novel / *Butch Cassidy and the Sundance Kid:* William Goldman / *Calamity Jane:* James O'Hanlon / *Cat Ballou:* Walter Newman and Frank R. Pierson from Toy Chanslor's novel *The Ballad of Cat Ballou* / *Cattle Queen of Montana:* Robert Blees and Howard Estabrook from Thomas Blackburn's story / *Cheyenne Autumn:* James R. Webb, suggested by Mari Sandoz's novel *Cheyenne Autumn* / *Cimarron:* Howard Estabrook from Edna Ferber's novel / *The Cowboy and the Lady:* S. N. Behrman and Sonya Levien from Leo McCarey and Frank R. Adams's story / *Dangers of the Canadian Mounted:* Franklin Adreon, Basil Dickey, Sol Shor and Robert G. Walker / *The Dark Command:* Grover Jones, Lionel Houser, F. Hugh Herbert and Jan Fortune from W. R. Burnett's novel *A Texas Iliad* / *The Deadly Companions:* Albert S. Fleischman from his novel / *Decision at Sundown:* Charles Lang Jr. from Vernon L. Fluharty's story / *Destry Rides Again:* Felix Jackson and Gertrude Purcell from Max Brand's novel / *Dodge City:* Robert Buckner / *The Duel at Silver Creek:* Gerald Grayson Adams and Joseph Hoffman from Gerald Grayson Adams's story / *Duel in the Sun:* David O. Selznick, adaptation by Oliver H. P. Garrett, suggested by Niven Busch's novel / *El Dorado:* Leigh Brackett from Harry Joe Brown's novel *The Stars in Their Courses* / *Escape from Fort Bravo:* Frank Fenton, Philip Rock and Michael Pate / *A Fistful of Dollars:* Sergio Leone and Duccio Tessari, inspired by Akira Kurosawa's film *Yojimbo* / *Flaming Star:* Clair Huffaker and Nunnally Johnson from Clair Huffaker's novel / *Fort Apache:* Frank S. Nugent, suggested by James Warner Bellah's story "Massacre" / *Forty Guns:* Samuel Fuller / *Frontier Gal:* Michael Fessier and Ernest Pagano / *Giant:* Fred Guiol and Ivan Moffat from Edna Ferber's novel / *Goin' to Town:* Mae West from Marion Morgan and George B. Dowell's story / *The Good, the Bad and the Ugly:* Sergio Leone, Luciano Vincenzoni, Agenore Incrocci and Furio Scarpelli from Sergio Leone and Luciano Vincenzoni's story / *Gunfight at the O.K. Corral:* Leon Uris, suggested by George Scullin's

article / *The Gunfighter:* William Bowers, Andre De Toth, Nunnally Johnson and William Bowers's story / *Gun Fury:* Roy Huggins and Irving Wallace from Kathleen B. George and Robert A. Granger's novel *Ten Against Caesar* / *The Halliday Brand:* George W. George and George F. Slavin / *Hang 'em High:* Leonard Freeman and Mel Goldberg / *The Hanging Tree:* Wendell Mayes and Halsted Welles from Dorothy M. Johnson's novel / *Heller in Pink Tights:* Dudley Nichols and Walter Bernstein from Louis L'Amour's novel / *High Noon:* Carl Foreman from John W. Cunningham's story "The Tin Star" / *Hombre:* Irving Ravetch and Harriet Frank Jr. from Elmore Leonard's novel / *Hondo:* Edward Grant from Louis L'Amour's story / *How the West Was Won:* James R. Webb, suggested by the series "How the West Was Won" in *Life* / *Hud:* Irving Ravetch and Harriet Frank Jr. from Larry McMurtry's novel / *The Indian Fighter:* Frank David and Ben Hecht from Ben Kadish's story / *The Iron Sheriff:* Seeleg Lester / *Jesse James:* Nunnally Johnson, research by Rosalind Shaffer and Jo Frances James / *Johnny Guitar:* Philip Yordan from Roy Chanslor's novel / *Jubal:* Russell S. Hughes and Delmer Daves from Paul Wellman's novel *Jubal Troop* / *Kansas Pacific:* Daniel Ullman / *The Kentuckian:* A. B. Guthrie Jr. from Felix Holt's novel *The Gabriel Horn* / *The King and Four Queens:* Margaret Fitts and Richard Alan Simmons from Margaret Fitts's story / *Lady from Cheyenne:* Warren Duff and Kathryn Scola from Jonathan Finn and Theresa Oakes's story / *The Last of the Fast Guns:* David P. Harmon / *The Last Sunset:* Dalton Trumbo from Howard Rigsby's novel *Sundown at Crazy Horse* / *Last Train from Gun Hill:* James Poe from Les Crutchfield's story / *The Law and Jake Wade:* William Bowers from Marvin H. Albert's novel / *The Left-Handed Gun:* Leslie Stevens from Gore Vidal's teleplay / *Little Big Man:* Calder Willingham from Thomas Berger's novel / *Lonely Are the Brave:* Dalton Trumbo from Edward Abbey's novel *Brave Cowboy* / *Lone Star:* Borden Chase from his story, based on Howard Estabrook's screen story / *The Magnificent Seven:* William S. Roberts, based on Akira Kurosawa's film *The Seven Samurai* / *The Man from Laramie:* Philip Yordan and Frank Burt from Thomas T. Flynn's *Saturday Evening Post* story / *The Man from the Alamo:* Steve Fisher and D. D. Beauchamp from Niven Busch and Oliver Crawford's story / *Man in the Saddle:* Kenneth Gamet from Ernest Haycox's novel / *Man in the Shadows:* Gene L. Coon / *The Man Who Shot Liberty Valance:* James Warner Bellah and Willis Goldbeck from Dorothy M. Johnson's story / *Man Without a Star:* Borden Chase and D. D. Beauchamp from Dee Linford's novel / *Many Rivers to Cross:* Harry Brown and Guy Trosper from Steve Frazee's story / *The Maverick Queen:* Kenneth Gamet and DeVallon Scott from Zane Grey's novel / *The Misfits:* Arthur Miller / *Montana Belle:* Horace McCoy and Norman S. Hall from M. Coates Webster and Howard Welsch's story / *Monte Walsh:* Lukas Heller and David Zelag Goodman from Jack Shaefer's novel / *My Darling Clementine:* Samuel C. Engle, Winston Miller and Sam Hellman from Stuart N. Lake's book *Wyatt Earp, Frontier Marshal* / *My Little Chickadee:* W. C. Fields and Mae West / *The Naked Dawn:* Nina and Herman Schneider / *The Naked Spur:* Sam Rolfe and Harold Jack Bloom / *Night Passage:* Borden Chase from Norman A. Fox's novel / *Northwest Mounted Police:* Alan LeMay, Jesse Lasky Jr. and C. Gardner Sullivan / *Northwest Stampede:* Art Arthur and Lillie Hayward, suggested by Jean Muir's *Saturday Evening Post* article "Wild Horse Round-Up" / *Oklahoma!:* Sonya Levien and William Ludwig from Richard Rodgers and Oscar Hammerstein II's musical based on Lynn Riggs's play *Green Grow the Lilacs* / *One-Eyed Jacks:* Guy Trosper and Calder Willingham from Charles Neider's novel *The Authentic Death of Hendry Jones* / *Only the Valiant:* Edmund H. North and Harry Brown from Charles Marquis Warren's novel / *The Ox-Bow Incident:* Lamar Trotti from Walter Van Tilburg Clark's novel / *The Painted Desert:* Jack Cunningham, Oliver Drake and John Rathmell / *Paint Your Wagon:* Alan Jay Lerner and Paddy Chayevsky from the Broadway musical by Lerner and Loewe / *The Plainsman:* Waldemar Young, Harold Lamb, Jeanie Macpherson and Lynn Riggs from Frank Wilstach's story "Wild Bill Hickok" and Courtney Ryley Cooper and Grover Jones's story "The Prince of Pistoleers" / *The Professionals:* Richard Brooks from Frank O'Rourke's novel *A Mule for the Marquesa* / *Pursued:* Niven Busch / *Rachel and the Stranger:* Waldo Salt from Howard Fast's story "Rachel" / *Rage at Dawn:* Horace McCoy from Hank Gruber's story / *Ramrod:* Jack Moffitt, Graham Baker and Cecile Kramer from Luke Short's story / *Rancho Notorious:* Daniel Taradash from Silvia Richard's novel *Gunsight Whitman* / *Rawhide:* Dudley Nichols / *The Red Pony:* John Steinbeck from his novel / *Red River:* Borden Chase and Charles Schnee from Borden Chase's novel / *Ride the High Country:* N. B. Stone Jr. / *Rio Bravo:* Jules Furthman and Leigh Bracket from B. H. McCampbell's story / *Rio Conchos:* Clair Huffaker and Joseph Landon from Clair Huffaker's novel / *Rio Grande:* James K. McGuinness from James Warner Bellah's novel *Mission with No Record* / *River of No Return:* Frank Fenton from Louis Lantz's story / *Rough Night in Jericho:* Sydney Boehm and Marvin H. Albert from Johnston McCulley's story / *The Rounders:* Burt Kennedy from Max Evans's novel / *Ruggles of Red Gap:* Walter DeLeon and Harlan Thompson, adapted by Humphrey Pearson from Harry Leon Wilson's play and novel / *Santa Fe Trail:* Robert Buckner / *The Searchers:* Frank S. Nugent from Alan LeMay's novel / *Shane:* A. B. Guthrie Jr. and Jack Sher from

Jack Schaefer's novel / *She Wore A Yellow Ribbon:* Frank Nugent and Laurence Stallings from two stories by James Warner Bellah / *The Showdown:* Dorrell and Stuart McGowan from Richard Wormser and Don Gordon's story in *Esquire* / *The Southerner:* Hugo Butler and Jean Renoir from George Sessions Perry's novel *Hold Autumn in your Hand* / *Springfield Rifle:* Charles Marquis Warren and Frank Davis from Sloan Nibley's story / *Stagecoach:* Dudley Nichols from Ernest Haycox's story "Stage to Lordsburg" / *Stars in My Crown:* Margaret Fitts from Joe David Brown's novel and adaptation / *Station West:* Frank Fenton and Winston Miller from Luke Short's novel / *The Stranger Wore a Gun:* Kenneth Gamet from John M. Cunningham's novel *Yankee Gold* / *Streets of Laredo:* Charles Marquis Warren from Louis Stevens and Elizabeth Hill's story, based on the film *The Texas Rangers* / *Support Your Local Sheriff!:* William Bowers / *Tall in the Saddle:* Michael Hogan and Paul P. Fix from Gordon Ray Young's novel / *3:10 to Yuma:* Halsted Welles from Elmore Leonard's story / *Thunder over the Plains:* Russell Hughes / *Tombstone:* Albert S. LeVino, Edward E. Parmore, Dean Franklin and Charles Beisner from Walter Noble Burns's book *Tombstone, the Toughest Town in Arizona* / *Tribute to a Bad Man:* Michael Blankfort from Jack Schaefer's story / *Treasure of the Sierra Madre:* John Huston from B. Traven's novel / *True Grit:* Marguerite Roberts from Charles Portis's novel / *The Unforgiven:* Ben Maddow from Alan LeMay's novel / *Union Pacific:* Walter DeLeon, C. Gardner Sullivan, Jesse Lasky Jr. and Jack Cunningham from Ernest Haycox's novel *Trouble Shooter* / *Treasure of the Sierra Madre:* John Huston from B. Traven's novel / *Vera Cruz:* Roland Kibbee, James R. Webb and Borden Chase / *The Violent Men:* Harry Kleiner from Donald Hamilton's novel / *The Virginian:* Howard Estabrook, dialogue by Edward E. Paramor Jr., adaptation by Grover Jones and Keene Thompson from Owen Wister's novel and Owen Wister and Kirk La Shelle's novel / *Viva Villa!* Ben Hecht, suggested by Edgecombe Pinchon and O. B. Stade's book / *Wagon Master:* Frank Nugent and Patrick Ford / *War Arrow:* John Michael Hayes / *Warlock:* Robert Alan Aurthur from Oakley Hall's novel / *The War Wagon:* Clair Huffaker from his novel *The Badman* / *The Westerner:* Niven Busch and Jo Swerling from Stuart N. Lake's story / *Western Union:* Robert Carson from Zane Grey's story / *Westward the Women:* Charles Schnee from Frank Capra's story / *The Wild Bunch:* Walon Green and Sam Peckinpah from Walon Green and Roy N. Sickner's story / *Winchester '73:* Robert L. Richards and Borden Chase from Stuart N. Lake's story

Acknowledgements

We sincerely thank the many people who generously helped us with support, advice, help, research, and loans from their collections: Peter Bateman of Larry Edmunds Bookshop, Jane Cloud of Captain Video, Sharon McGowan, Dennis Mills and Michelle Normoyle, Jane O'Hara and Helen Ryane, Mike Orlando of Hollywood Canteen, Schroeder, Alain Silver, Rick Staehling, Kevin Taylor of Hollywood Cowboys, and John Teegarden and Dale Nash.

We are also grateful to our designers and agents at Byzantium Books—Barbara Hodgson, Isabelle Swiderski, and Nick Bantock—as well as to our editors, Annie Barrows and Karen Silver at Chronicle Books, and our proofreader, Ellen Klages.